creative edge TYPE

creative edge

TYPE

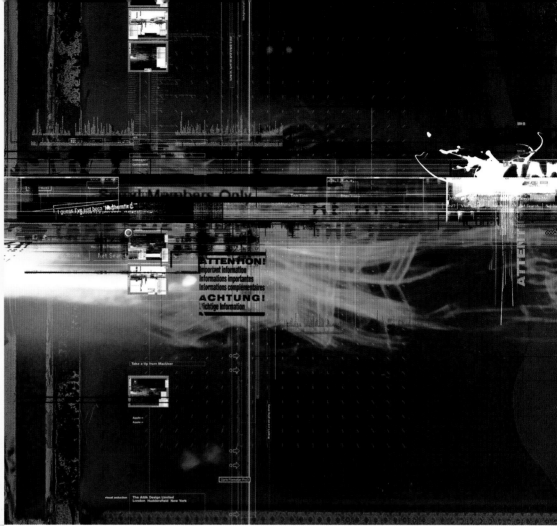

lynn haller

HBI

Creative Edge: Type

First published 1999 by North Light Books.

Distributed outside the United States and
Canada by Hearst Books International
1350 Avenue of the Americas
New York, NY 10019
Telephone: (212) 261-6770
Fax: (212) 261-6795

Other fine North Light Books are available from your local bookstore, art supply store or direct from the publisher.

03 02 01 00 99 5 4 3 2 1

Library of Congress Cataloging-in-Publication Data

Haller, Lynn.
 Type / Lynn Haller.
 p. cm. — (Creative edge series)
 Includes index.
 ISBN 0688-17178-8 (alk. paper)
 1. Layout (Printing) I. Title. II. Series.
Z246.H35 1997
686.2'252—dc21 97-23616
 CIP

Edited by Lynn Haller
Production edited by Michelle Howry
Designed by Brian Roeth
Production coordinated by Kristen Heller

The permissions on page 142 constitute an extension of this copyright page.

acknowledgMENTS

Many thanks to Brian Roeth, who designed a vibrant cover design and flexible interior design for

this book, and to Michelle Howry, who saw this book through production. Also, thanks to the

designers featured in this book (as well as their support staff), who generously shared their work

and their thoughts, and patiently fielded my many calls, faxes and E-mail messages.

table of

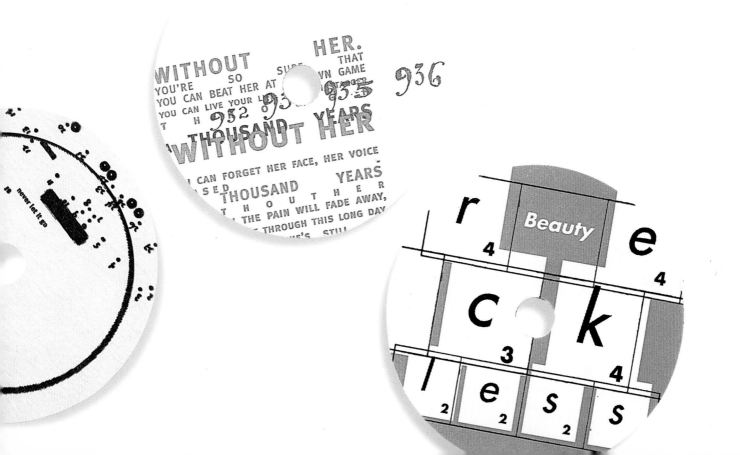

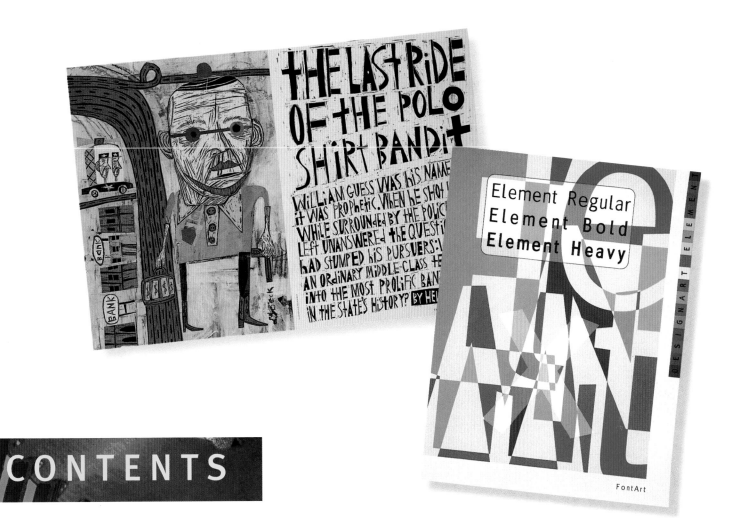

CONTENTS

In the past twenty years, a revolution has taken place in the world of typography—

designers have wrested it out of the hands of typesetters and claimed it as their own. Where

type once was simply specced, set and corrected, it is now faxed, crumpled, collaged, layered

and digitally manipulated. What typography may have lost in precision, it has gained in

expressiveness—a fact that's made apparent when paging through this, the second book in the

Creative Edge series.

It's interesting to imagine how a designer from the 1950s or 1960s—transported into

the present in his stylish time machine—would react to this compilation; would he (and no doubt

it would be a he) recoil in horror at the typo-

graphical abuses on display, or would he

gaze with envy upon the infinite array of possibilities available to designers today? Would he find

today's typography exciting or unreadable—or both?

Undoubtedly, what's happened to typography is a mixed bag. For every wonderful new

font that's designed today, there are at least a dozen derivative and ill-conceived (or not really

conceived at all) fonts trolling for designers' attention—and lunch money. Like any other tool,

computers can be used well or poorly: While they have been a boon to designers with bright

ideas and poor rendering skills, they have likewise encouraged anyone with a copy of

Fontographer or Photoshop to think they can make some easy money designing type ("design-

ing" meaning taking an existing typeface, making some minor adjustments, and calling it their

own). And for every designer who is now finally able to achieve the typographic results he or she

imagined without having to pay for a typesetter's revisions, there is at least another designer

who could well benefit from a typesetter's counsel. As always, great tools are no substitute for a

great eye—or an educated one.

Those without educated eyes would do well to scrutinize the examples in this book—

EDITOR

they will learn from some of the best in the

business the possibilities available in

designing with type today. In the hands of these designers, type does more than just talk—it

emotes, it surprises, it moves. The examples you'll find in this book prove that treating type with

respect and treating type with a sense of exploration and play need not be mutually exclusive.

When you page through this book, I hope that the same sense of joy these designers brought to

their work is communicated to you, as it was to me—and moreover, that you might be inspired to

bring this same sense of joy to your own work.

organic
and
handmade

section ONE

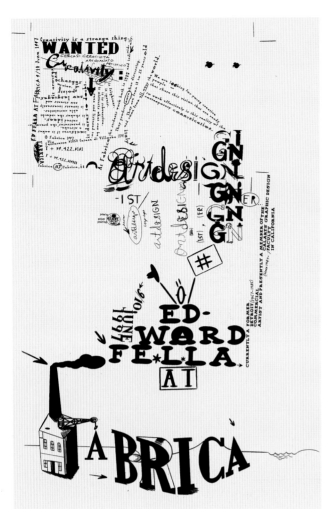

FABRICA FLYER

ART DIRECTOR/DESIGNER: Edward Fella

ILLUSTRATOR: Edward Fella

CLIENT: Edward Fella/designer and design educator

COLORS: One, black

PRINT RUN: 350

COST PER UNIT: $.03 or $.04 US

TYPEFACES: hand-lettering, OutWest

TYPEFACE DESIGNER: Edward Fella (hand-lettering, OutWest)

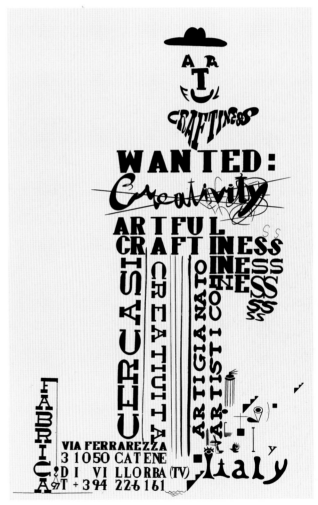

CONCEPT: Edward Fella says that the idea behind this flyer was that "'artful craftiness' is a better description or definition of the word *creativity* that was wanted by the Italian design school Fabrica. The face is a cowboy or clown or a gondola man. The composition on the back also refers to the map of Italy. The front has me agitating on a soapbox outside a factory about 'art design' while becoming a form of 'art design' due to the style it's drawn in."

MINE™

ART DIRECTORS: Joshua Berger, Niko Courtelis, Pete McCracken

DESIGNERS: Joshua Berger, Niko Courtelis, Pete McCracken, Riq Mosqueda, Marcus Burlile, Scott Clum, Denise Gonzales Crisp, Greg Maffei, Carlos Segura, Smokebomb Studios, Martin Venezky

CLIENT/PRODUCT: Champion International Paper/paper

SOFTWARE: QuarkXPress, Adobe Photoshop, Adobe Illustrator, Macromedia FreeHand

COLORS: Four, process, plus two varnishes

PRINT RUN: 27,500

TYPEFACES: Roscent, Hybrid, Flytrap, Capitalis Pirata, Ghetto Prince, Centrifuga

TYPEFACE DESIGNERS: Angus R. Shamal (Roscent), Christian Küsters (Hybrid), Marcus Burlile (Flytrap), Roland Hess (Capitalis Pirata), Frank Ford (Ghetto Prince), Ermin Mededovic (Centrifuga)

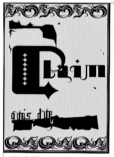

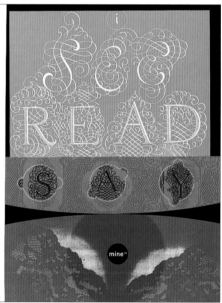

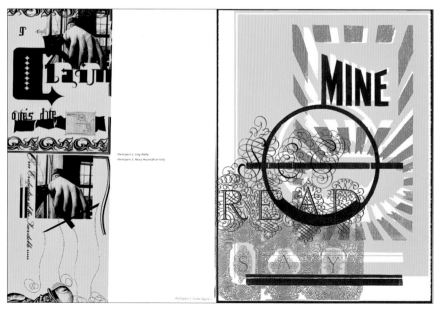

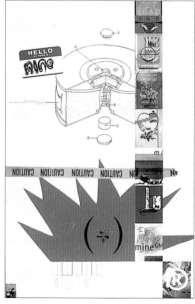

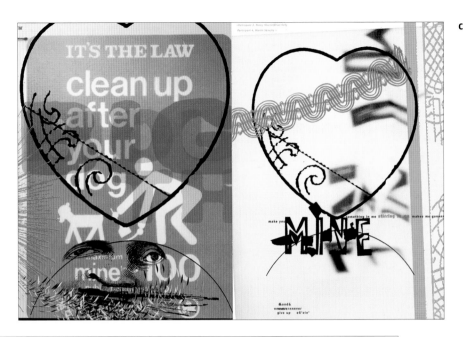

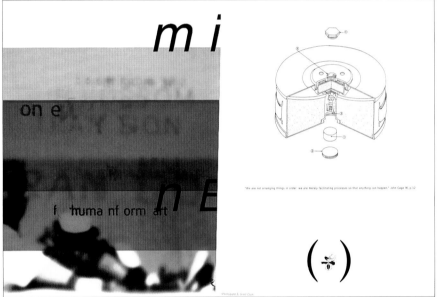

CONCEPT: "Mine™ is an installation on paper, investigating the nature of ownership and collaboration in the digital age," says Joshua Berger of Plazm Media, Inc. "Beginning with a batch of raw materials provided by Plazm, eight designers from around the country were asked to alter, recombine, add to, subtract from or modify a single graphic design project as it circulated among them. At each stage the sequential edits returned to Plazm for compilation. Upon completion, the Mine™ project revealed a set of at once discrete and incremental design solutions, overlapping and diverging in unexpected ways. Interestingly, two participants were unable to proceed due to prior corporate commitments, and another dropped out due to ideological concerns, refusing to create something for such a 'commercial vehicle.'"

SPECIAL PRODUCTION TECHNIQUES: Tinted gloss and matte varnish were used on a six-color press.

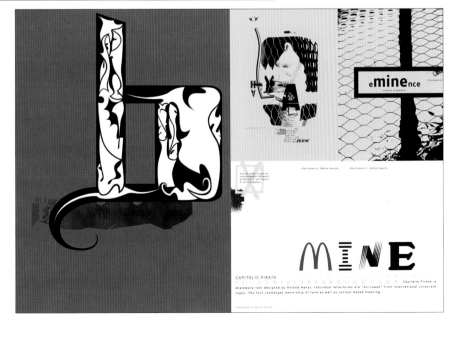

QUICKTURN PLAYING CARDS/DAC GIVEAWAY

STUDIO: Jennifer Sterling Design, San Francisco, CA

ART DIRECTOR/DESIGNER: Jennifer Sterling

ILLUSTRATORS: Jonathon Rosen, Jennifer Sterling

CLIENT/SERVICE: Quickturn Design Systems, Inc./supplier of design verification solutions for the electronics industry

SOFTWARE: Adobe Photoshop, Adobe Illustrator, QuarkXPress

COLORS: Two, match

PRINT RUN: 2,500

COST PER UNIT: $4.50 US

TYPEFACE: Hand-drawn and various

CONCEPT: "Quickturn Design Systems, Inc. is a leading supplier of design verification solutions for the electronics industry," Jennifer Sterling says about the client who commissioned these playing cards. "Quickturn pioneered emulation technology which allows users to test and fine-tune their chip designs before fabrication. As an exhibitor at DAC (Design Automation Conference), Quickturn wished to expand on their marketing message 'the Magic of Emulation.' The magic team of Penn & Teller created a specially scripted performance relating to EDA. The playing cards, featured here, illustrate humorous magical attempts on one side and the marketing message 'the Magic of Emulation' on the other. Enclosed in a custom-designed metal case is a complete deck of cards (shrink-wrapped) with one

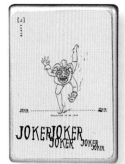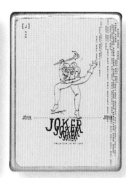

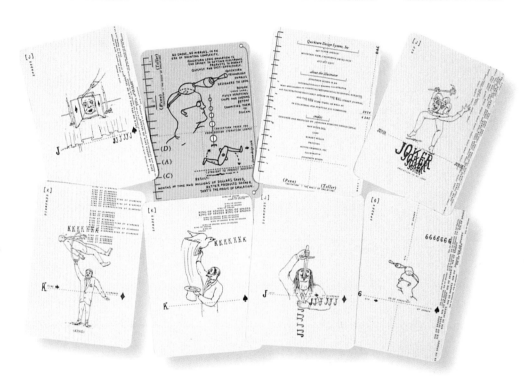

laser-cut metal wild card.

"While a promotional item was one of the deliverables requested by the client, we wanted to create a product that would not be thrown away. The playing cards were also created in a limited edition to further decrease any excessive waste (better to keep them wanting more, right?). As it turned out, not only did the CEOs want them, but their children did too."

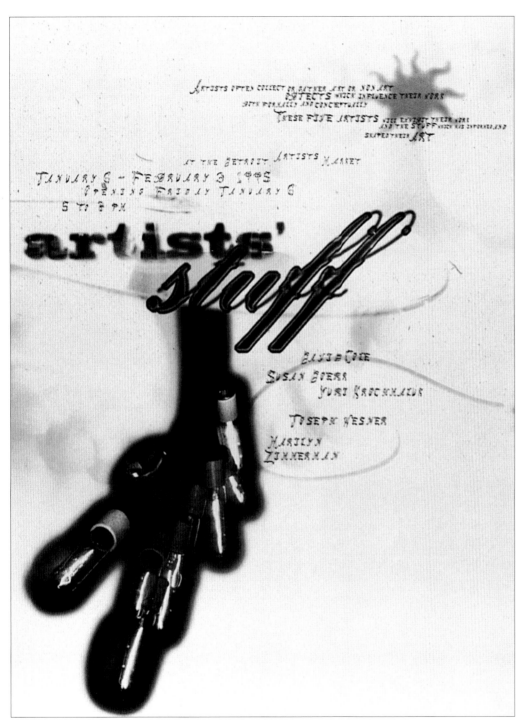

ART DIRECTOR/DESIGNER: Doug Bartow

CLIENT/SERVICE: Detroit Artist's Market/gallery

SOFTWARE: Adobe Photoshop, Adobe Illustrator, QuarkXPress

COLORS: Two, match

PRINT RUN: 5,000

TYPEFACES: Chocolateer, Kuenstler Script (manipulated), Blackoak (manipulated)

TYPEFACE DESIGNER: Matt Owens (Chocolateer)

CONCEPT: Bartow describes this piece as "an announcement to a show which featured artists' work as well as some selected 'stuff' from their studios: objects and collectables the artists kept near their creative processes."

ORGANIC AND HANDMADE 15

PLAY THE GAME (YOU CAN'T WIN) POSTER CAMPAIGN

STUDIO: Art Center College of Design, Pasadena, CA

DESIGNERS: Merlin Lembong, Sharon Tani

CLIENT/SERVICE: CEPA Gallery, Buffalo, NY/"Uncommon Traits/ReLocating Asia, Part III" public art exhibition

SOFTWARE: Adobe Photoshop, Adobe Illustrator

COLORS: Four, process

TYPEFACES: DIN Schriften, Meta, Mrs. Eaves, Sabon, Handel Gothic, News 701

CONCEPT: "This series of storefront-window posters served as a campaign to increase awareness about specific issues surrounding Asian-American culture," say Merlin Lembong and Sharon Tani. "Some of the themes include revealing how historical anti-Asian laws have influenced self-identity, how the media has perpetuated stereotypes and how slang terms have negatively defined Asian-Americans over the last century. The visual clues and verbal puns of this series were designed to express an irreverent outrage to our contemporary society but also to poignantly illustrate the process of rediscovering a culture.

"Controversies emerging from race issues are always a 'push-pull' test. In this series, the negotiation is depicted in the form of relentless games. The metaphor represents the challenge of coping with racism through intelligence, strength, strategy and, no doubt, lots of sportsmanship. The posters include recognizable childhood games which hold a universal appeal, but also display stereotypical characterizations and ghostly images to indicate that there is much more underlying this situation. The use of diaries, artifacts and personal belongings also indicates the significance of cultural inheritance and the memory of what gets lost in the struggle."

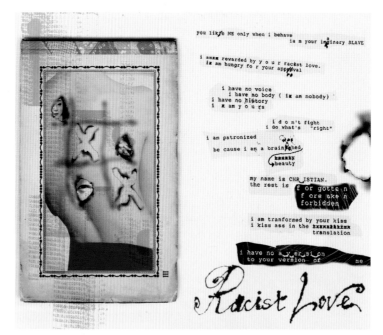

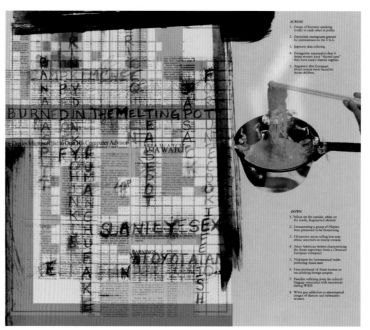

SPECIAL TYPE TECHNIQUES:

"Most of the type was custom-created in order to emphasize the unique 'storytelling' aspect of each piece," say Lembong and Tani. "Many elements of self-identity issues involve personal experience and these ideas had to be conveyed in a symbolic yet individualized manner. Rubber-stamping letters, then photocopying them through a fax machine, provided a raw and immediate impression. Typewritten passages, with the inclusion of copyediting marks, were meant to convey conflict and instability. Much of the text which was handwritten with ink on absorbent paper towel or lettered with pastel chalk was created to show a visual contrast between the structure of history and a more loose interpretation of an ethnic reality. Experimental typography alongside computer-generated type communicates a merging of intimate thoughts with bold arguments."

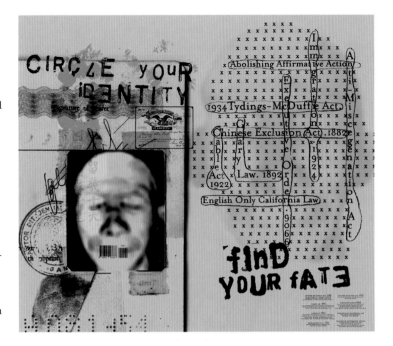

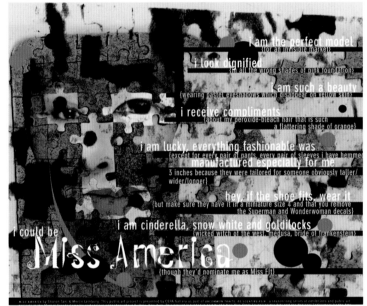

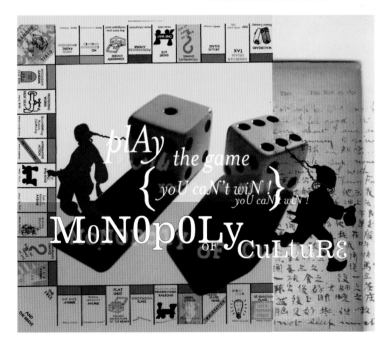

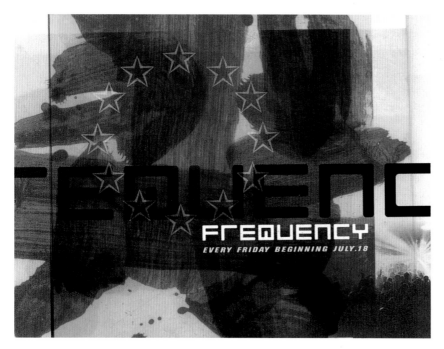

FREQUENCY FLYER

ART DIRECTOR/DESIGNER: Paul Martinez

CLIENT/SERVICE: Golden Voice/club promotions

SOFTWARE: Adobe Photoshop, QuarkXPress

COLORS: Four, process

PRINT RUN: 10,000

TYPEFACE: Kryptic

CONCEPT: "I wanted to create a flyer which had both a digital or mechanical feel along with a more natural humanistic warmth," says designer Paul Martinez of this club flyer.

INSPIRATION: "Electronic music and Japanese paintings," says Martinez.

"TEXAS MONTHLY" SPREAD

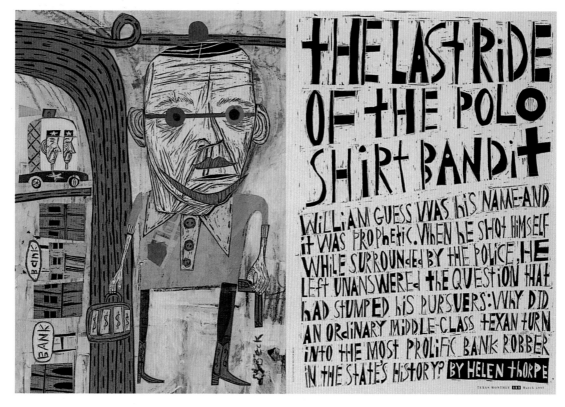

ART DIRECTOR/DESIGNER/STUDIO: D.J. Stout/ *Texas Monthly*

ILLUSTRATOR/STUDIO: Melinda Beck/Melinda Beck Studio

CLIENT/PRODUCT: *Texas Monthly*/magazine

COLORS: Four, process

TYPEFACE: hand-lettering

TYPEFACE DESIGNER: Melinda Beck

CONCEPT: "This piece illustrated the story of the most prolific bank robber in Texas history," says Melinda Beck.

SPECIAL TYPE TECHNIQUES: The typeface was created using India ink and scratchboard.

SPECIAL PRODUCTION TECHNIQUES: The piece was created using collage, scratchboard and acrylic paint.

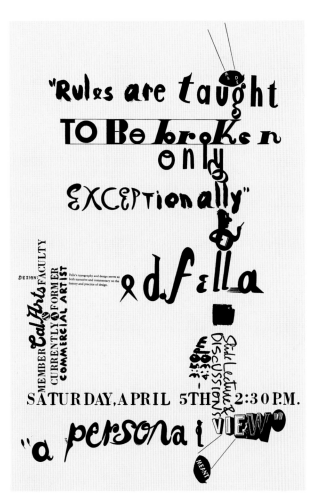

RULES FLYER

ART DIRECTOR/DESIGNER: Edward Fella

ILLUSTRATOR: Edward Fella

COLORS: One, black

PRINT RUN: 500

COST PER UNIT: $.04 US

TYPEFACES: hand-lettering

CONCEPT: Edward Fella says this flyer commemorating one of his lectures addresses the notion that his work is simply about breaking the rules; he meant to point out that at CalArts, where he teaches, he and his colleagues teach that the rules are to be broken only exceptionally—in both senses of that phrase.

As with other pieces by Fella on pages 11 and 24, this flyer was designed to be distributed after his lecture, so that students would have the opportunity to design the actual announcement/invitation for the lecture.

SPECIAL TYPE TECHNIQUES: "All the text was hand-lettered (with the exception of very small text lines, which were taken from the conference announcement bios)," says Fella. "What text that wasn't hand-lettered was taken from two typefaces I designed, one a brush face and the other Bodoni that I reworked by adding extra weight to some of the serifs. In both cases, I simply draw out the twenty-six letters of the alphabet and then photocopy the number of letters I need for the lines and just paste them down."

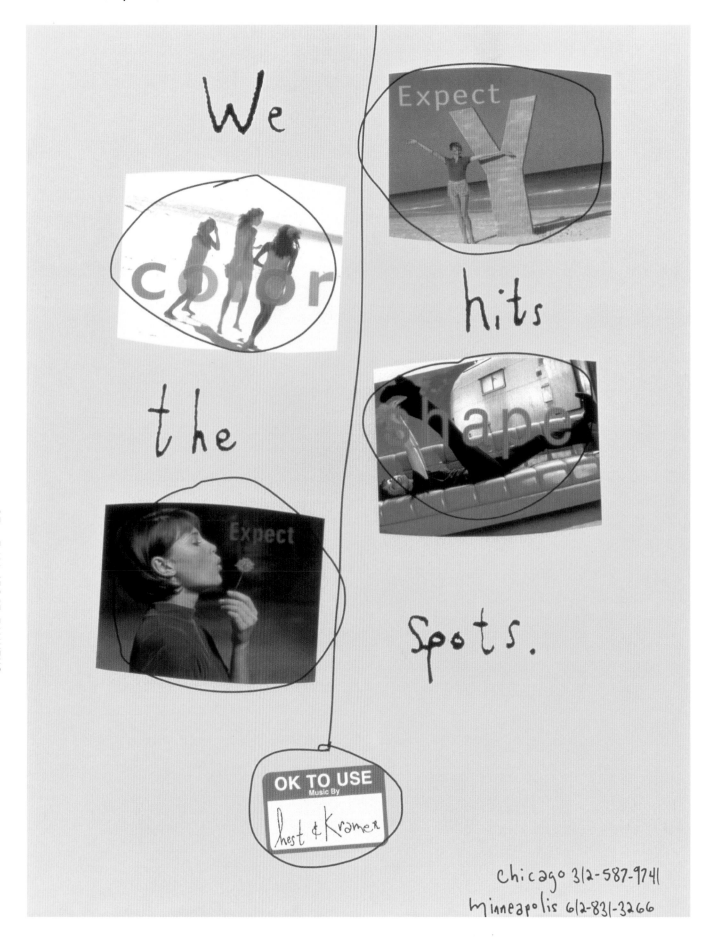

STUDIO: Design Guys, Minneapolis, MN

ART DIRECTOR: Steven Sikora

DESIGNER: Mitch Morse

PHOTOGRAPHY: Video stills from TV spots

CLIENT/PRODUCT: Hest & Kramer/music for advertising

SOFTWARE: Adobe Photoshop, Adobe Illustrator, Adobe Streamline, QuarkXPress

COLORS: Four, process

PRINT RUN: Distribution of *Ad Age Creativity* magazine

TYPEFACE: Sylvester (hand-drawn and digitized using Adobe Streamline)

CONCEPT: "Hest & Kramer write and produce original music for television and radio advertising which sounds like radio hits. This trade ad is promoting a highly successful series of TV spots for Target stores," says Steven Sikora of Design Guys about this advertisement.

INSPIRATION: "Our client's offbeat and hysterical sense of humor."

SPECIAL PRODUCTION TECHNIQUES: The piece juxtaposes hand-drawn type against video screen grabs.

SPECIAL COST-CUTTING TECHNIQUES: All photographic imagery was screen grabs from TV spots.

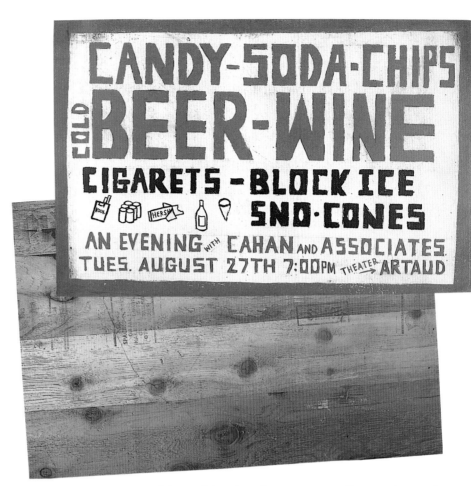

STUDIO: Cahan and Associates, San Francisco, CA

ART DIRECTOR: Bill Cahan

DESIGNER: Bob Dinetz

ILLUSTRATOR: Bob Dinetz

PHOTOGRAPHER: Holly Stewart

CLIENT/SERVICE: San Francisco Creative Alliance/WADC/Artists in Print/design education

COLORS: Four, process

PRINT RUN: 5,000

TYPEFACE: hand-lettering

CONCEPT: Because a lecture about graphic design might not be enough to encourage participation, this poster highlights other reasons people may want to attend: food and drink. The style of the poster and the convenience-store approach to the copy are responses to the usually slick nature of such promotions.

MARKO LAVRISHA PHOTOGRAPHY PROMOTION

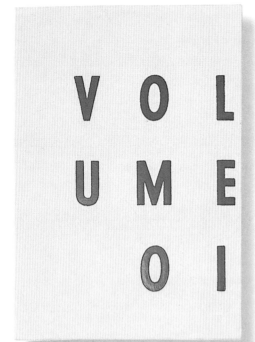

STUDIO: Jennifer Sterling Design, San Francisco, CA

ART DIRECTOR: Jennifer Sterling

DESIGNER: Amy Hayson

TYPOGRAPHER: Jennifer Sterling

WRITER: Eric LaBrecque

PHOTOGRAPHER: Marko Lavrisha

CLIENT/SERVICE: Marko Lavrisha Photography/photography

SOFTWARE: Adobe Photoshop, Adobe Illustrator

COLORS: Four, process over three, match

PRINT RUN: 5,000 (per volume)

COST PER UNIT: $15 US (each volume)

TYPEFACES: hand-drawn and various existing

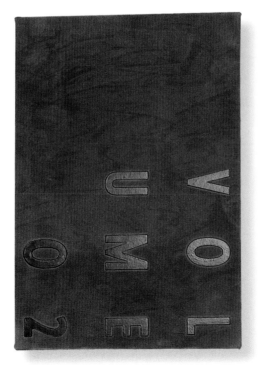

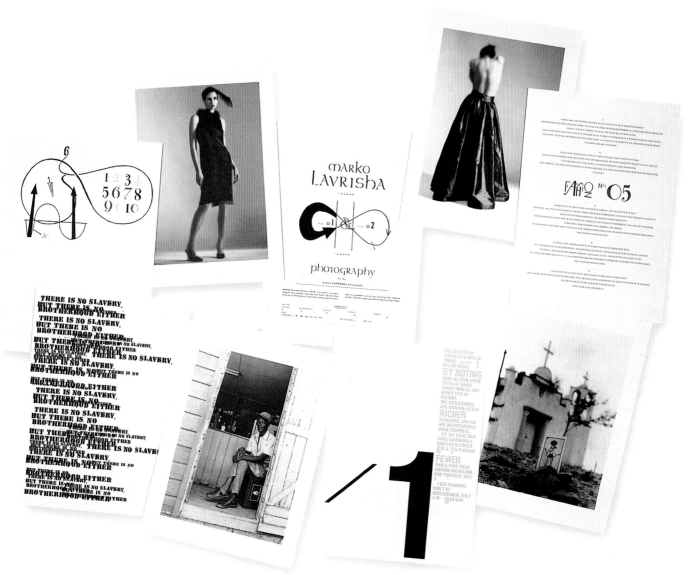

CONCEPT: Jennifer Sterling describes the objective of this photographer's promotion piece as "to create a portfolio of works that reflected five areas of work and photography sensibilities. The portfolio consolidates the photographer's portfolio into five areas of work consisting of but not limited to fashion, location, product, concept and miscellaneous. These were then divided into Volume 1 and Volume 2 slipcases, one for black-and-white images and the other for color.

Each card contains a piece of a story that is continued throughout the series of cards. The typography and design reflect the story line and the mood of the photography. The book is modular and can be geared towards specific industries. When received by clients it is as if they are being given a gift and the beauty of the photography is more likely to make a lasting impression."

MEMPHIS FLYER

ART DIRECTOR/DESIGNER: Edward
 Fella

ILLUSTRATOR: Edward Fella

CLIENT/SERVICE: Edward
 Fella/designer and design
 educator

COLORS: One, black

PRINT RUN: 350

COST PER UNIT: $.03 or $.04 US

TYPEFACES: hand-lettering,
 Mergenthaler Linotype Extra Bold
 (statted out of a 1924 font book)

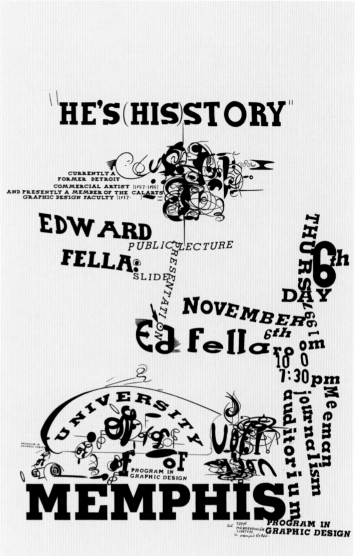

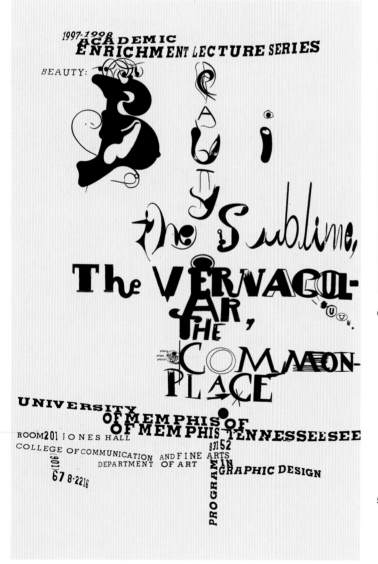

CONCEPT: Edward Fella says that the
 idea behind this flyer for one of his
 lectures was that "by now I'm 'his-
 tory' and my lectures about my
 work simply become my story
 (he's 'his story')." The lettering
 of the words "The sublime, The
 vernacular, The commonplace" is
 a take-off on the title of the lecture
 series.

SPECIAL TYPE TECHNIQUES: Some of
 the typography is photocopied,
 rephotocopied and distorted and
 then rearranged and pasted
 together.

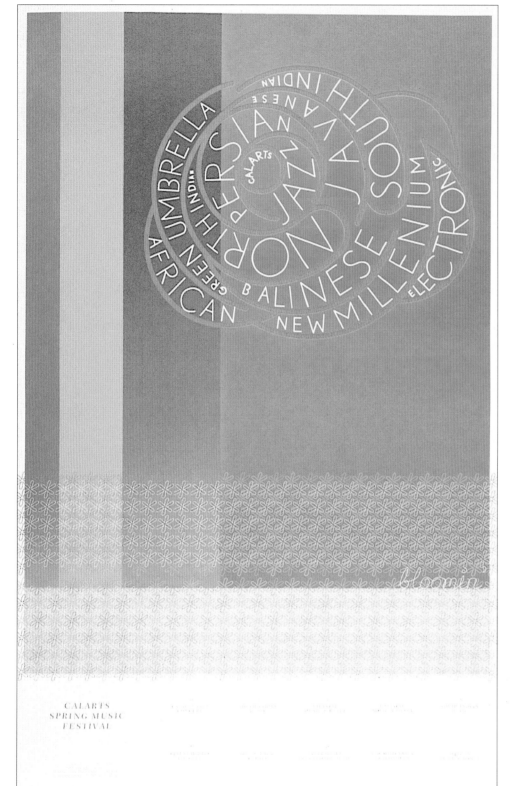

STUDIO: California Institute of the Arts, Office of Public Affairs, Valencia, CA

ART DIRECTOR/DESIGNER: Caryn Aono

ILLUSTRATOR: Caryn Aono

CLIENT/SERVICE: CalArts School of Music/four-year private college

SOFTWARE PROGRAMS USED: QuarkXPress, Macromedia FreeHand

COLORS: Four, match

PRINT RUN: 2,000

TYPEFACE: Fairfield, Nobel, Handy Script

TYPEFACE DESIGNER: Jeffery Keedy (Handy Script)

CONCEPT: The designer of this music festival poster, Caryn Aono, had a simple goal when designing it: To make it "big, bold, colorful and visible in the dark, dank hallways [of CalArts]."

INSPIRATION: "The client's request that it look like it was 'bloomin'," says Aono.

CSCA CREATIVE BEST CATALOG

STUDIO: Automatic Art and Design, Columbus, OH

ART DIRECTOR/DESIGNER: Charles Wilkin

ILLUSTRATOR: Charles Wilkin

PHOTOGRAPHERS: Chas Krider, Tracey Jolley

CLIENT/SERVICE: Columbus Society of Communicating Arts/local design organization

SOFTWARE: QuarkXPress

COLORS: Four, process

PRINT RUN: 600

COST PER UNIT: pro bono

TYPEFACES: Folio, Trixie, Broken

CONCEPT: "Every year the Columbus Society of Communicating Arts holds its Creative Best competition, and a book is produced to document the winning entries," says designer Charles Wilkin. "The 1996 book is a departure from the traditional award book format and uses the winning entries to create the book. Each entry was reassembled into collages and then used as a graphic. By taking the work out of context, the book becomes a representation of the design competition while allowing it to take on a separate identity."

SPECIAL TYPE TECHNIQUES: Photocopied and collaged type

SPECIAL COST-CUTTING TECHNIQUES: "All design, separations and printing were donated. This book was done entirely for free!" says Wilkin.

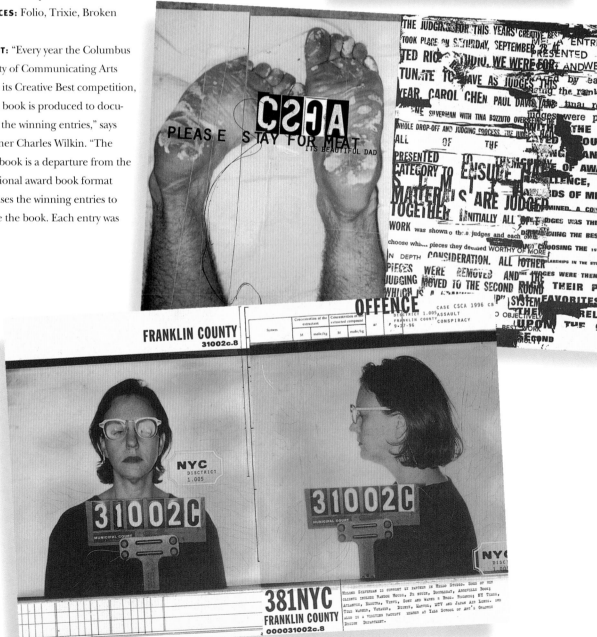

ENTRY08
WARD OF MERIT
MORE see below

TAKEFIVEPOSTER5

MINDSMOREK

EITHNOVICKIW

RITERJENNIFER

BLUMBERGTYPOGR

APHERDWIGHTYAEGERP

RINTERATLASPHOTOG

RAPHERWILLSHIV

ELY

5MINDS
5MINDS 5YEARS 5DANCES
Wednesday–Sunday, November 1–5, 1995

VELOUR
a delicious font catalogue

TO ORDER
CHARGE YOUR CREDIT CARD
BY PHONE AT 614
OR FAX US YOUR ORDER

IC
AR T
AND DES
IGN CLIENT
PROTOTYPE
DES
IGN/
CHARLES
LKIN
AWARD
OF
MER

AUTOMA
IC
AR T SUBMIT
AND DES
IGN CLIENT
PLAZM MAGAZINE
CHARLES WILKIN
ILLUST
DISK DUPLICATION
DISK DUPLICATION RATOR
DISK O TAPE ART DIRECT
WI ION
JOSH BE
RGER-
CHARLES WI
LKIN
AWARD
OF

ENTRY22/36
AUTOMATIC ← see above
IT///////

high gate
PROPERTIES
FIRE
HOUSE 101
ENTRY42/33 AND DES
FIREHOUSE 101 IGN
WARD OF MERIT KIRK
ROCK THE ARD S
VOTE with
G101-MTV
art shirt art
director designer carl
OS
SEGURA
ILLU
STR
ATOR
KIRK
animax
rich ARD
SMITH

JIMI HENDRIX PACKAGING

STUDIO: Smay Vision, New York, NY

ART DIRECTORS/DESIGNERS: Stan Stanski, Phil Yarnall

CLIENT: Experience Hendrix/MCA Records

SOFTWARE: QuarkXPress, Adobe Photoshop, Adobe Illustrator

COLORS: Four, process

TYPEFACE: hand-lettering

CONCEPT: "*First Rays of the New Rising Sun* was the album Jimi Hendrix was working on when he died," say Stan Stanski and Phil Yarnall of Smay Vision. "It was never fully completed, but it was the first record where Jimi had complete creative control of the project. It was also the first release from Experience Hendrix Records (the Hendrix-family–owned label) in 1997. They wanted the interior to have a very 'hands-on' feel, so we decided to use Jimi's notes, sketches and lyrics layered through-out the package."

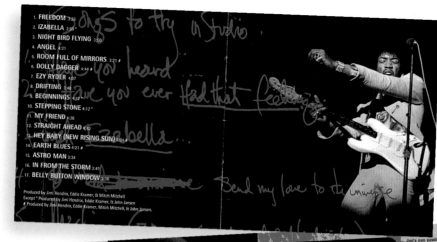

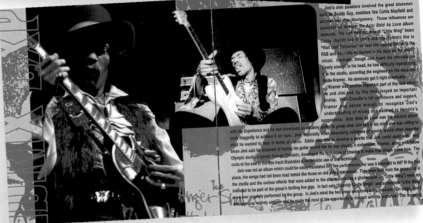

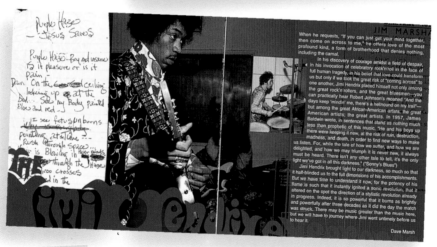

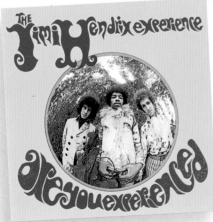

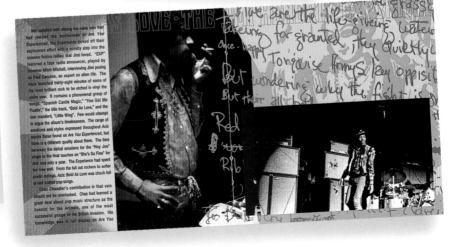

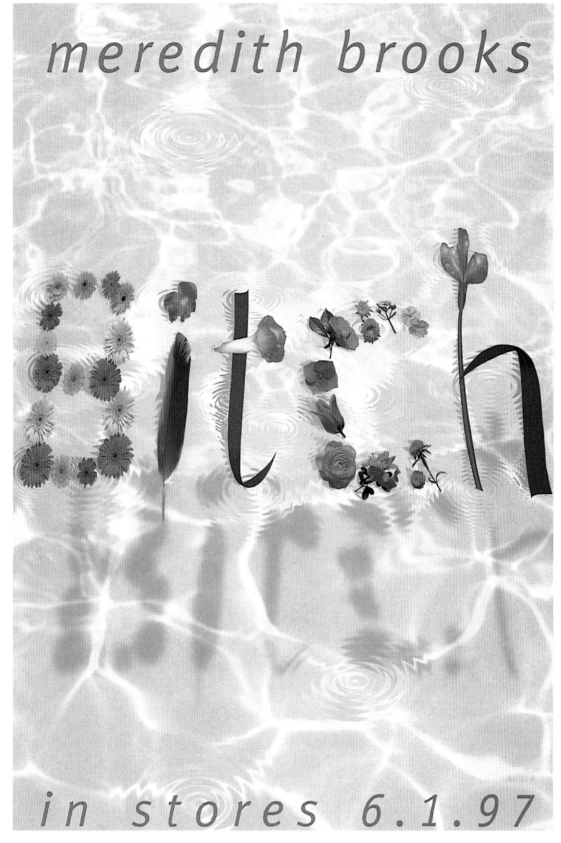

meredith brooks

in stores 6.1.97

ART DIRECTOR/STUDIO: Jeff Fey/ Capitol Records, Los Angeles, CA

DESIGNER/STUDIO: Norman Moore/Design Art, Inc., Los Angeles, CA

CLIENT/SERVICE: Capitol Records/record company

SOFTWARE: Adobe Photoshop, QuarkXPress

COLORS: Four, process

TYPEFACE: Gill Sans

CONCEPT: The idea behind the unusual typographic treatment of the poster's centerpiece word was "to take a hard-edged word and graphically redefine it in a soft, light manner," according to designer Norman Moore.

INSPIRATION: "Use of natural elements—water, flowers, shadow."

STUDIO: Spur, Baltimore, MD

ART DIRECTOR/DESIGNER: David Plunkert

ILLUSTRATOR: David Plunkert

CLIENT/SERVICE: Spur/illustration

SOFTWARE: Adobe Illustrator, Adobe Photoshop, QuarkXPress

COLORS: Four, process, and five, match

PRINT RUN: 1,500

TYPEFACES: Akzidenz Grotesk, Serifa Letter Gothic, various display

CONCEPT: David Plunkert describes this piece as "a bookshelf-quality promotional book combining philosophy and personally created illustrations with a full-color portfolio of illustrations created for clients."

INSPIRATION: "Max Ernst and industrial catalog design of the 1940s."

SPECIAL TYPE TECHNIQUES: Hand-drawn fonts were photocopied, scanned and manipulated in Photoshop.

SPECIAL PRODUCTION TECHNIQUES: "The book is double-sided. One side features an eight-page 'philosophy' section. The other features a full-color portfolio."

COST-CUTTING TECHNIQUES: "The book combines a one-color section and four-color section with a three-over-two match color cover. Different stocks were used for each section for contrast. Cost per unit was held down by running all the books in the series together."

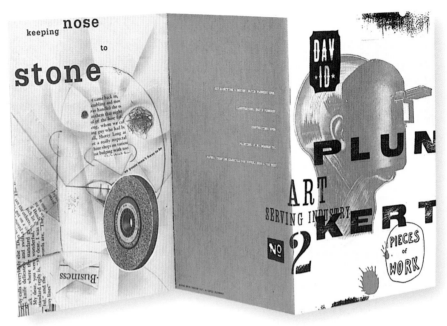

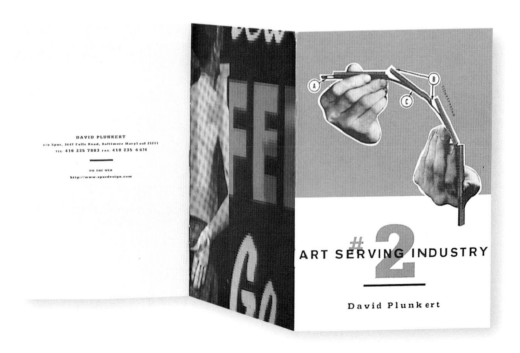

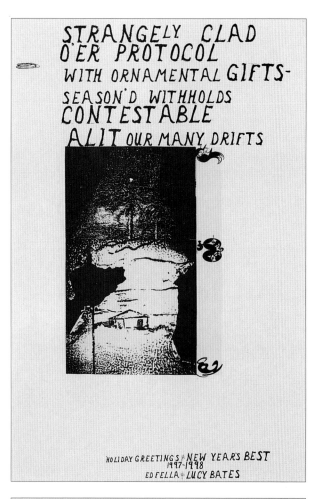

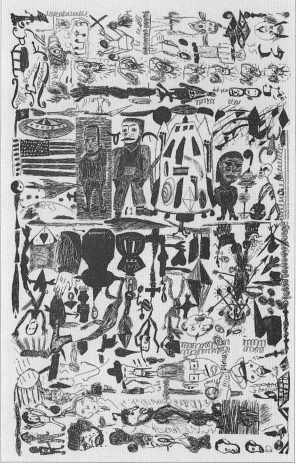

HOLIDAY GREETINGS FLYER

ART DIRECTOR/DESIGNER: Edward Fella

ILLUSTRATORS: Kagiso Fella, Larona Fella

PHOTOGRAPHER: Edward Fella

CLIENTS: Edward Fella and Lucy Bates

COLORS: One, black

PRINT RUN: 500

COST PER UNIT: $.05 US

TYPEFACE: hand-lettering

TYPEFACE DESIGNER: Lucy Bates

CONCEPT: This holiday flyer designed and distributed by Edward Fella was a family affair, with Fella's wife and two nephews involved in the creation of its type and images. The back of the piece is a collage of drawings done by Fella's nephews, aged nine and ten, which Fella photocopied from a sketchbook they sent him from their African home. The subject matter reflects typical young boy interests, but Fella selected and arranged drawings that he felt would make the most interesting composition and content. Fella feels that the front image vaguely resembles the design of a book cover with the three "fellaparts" (dingbats designed by Fella) representing the Three Wise Men's gifts and/or a book's spine.

SPECIAL TYPE TECHNIQUES: Edward Fella's nondesigner wife, Lucy Bates, did the typeface for this piece. She drew out the twenty-six letters and Fella photocopied as many as he needed and cut and pasted them.

SPECIAL PRODUCTION TECHNIQUES: The Christmas star was actually a spot of correction fluid that Fella hand-applied to all of the 500 flyers.

type as image

section TWO

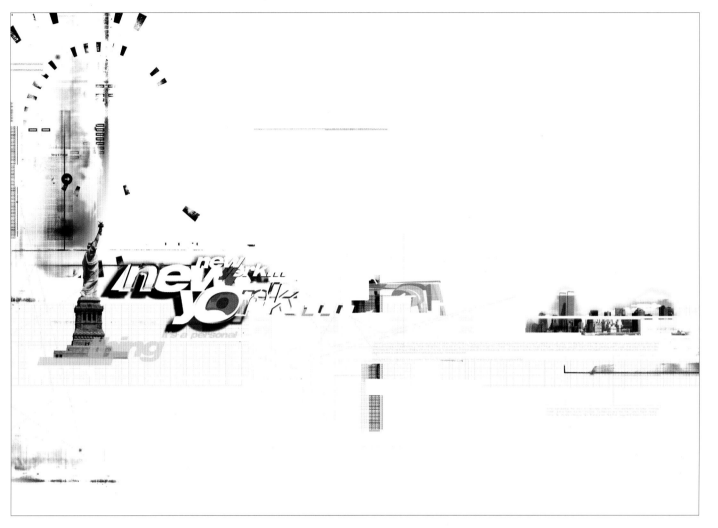

STUDIO: The Attik, Huddersfield, England; London, England; and New York, NY

PRESIDENT/EXECUTIVE PRODUCER: William Travis

GROUP CREATIVE DIRECTOR/ MANAGING DIRECTOR: James Sommerville

GROUP CREATIVE DIRECTOR/SALES DIRECTOR: Simon Needham

CREATIVE DIRECTOR, NEW YORK: Simon Dixon

DESIGNER: Steven Wills

PHOTOGRAPHER: Steven Wills

CLIENT/SERVICE: The Attik/design

SOFTWARE: Macromedia FreeHand, Adobe Photoshop, Infini-D

COLORS: Four, process, plus one, match

TYPEFACE: Swiss 721 Black Extended (with 20 percent skew)

CONCEPT: This spread from The Attik's publication entitled *Noise* draws on Steven Wills's personal experiences during a recent visit to New York.

"INDUSTRIAL NOISE" CD PACKAGE

STUDIO: Kerosene Halo, Chicago, IL

ART DIRECTOR/DESIGNER: Thomas Wolfe

PHOTOGRAPHER: Thomas Wolfe

CLIENT/SERVICE: AV Deli/audio production house

SOFTWARE: Adobe Illustrator, Raydream Designer, Adobe Photoshop, QuarkXPress

COLORS: One, match

PRINT RUN: 1,000

TYPEFACE: Banco

CONCEPT: "This CD of sound effects was created by twisting snippets from old B movies into a collection of industrial sound bytes," says Thomas Wolfe of Kerosene Halo. "After listening to the music it was hard not to be inspired by childhood memories of Godzilla movies. We wanted to portray this in a design that held reference to those B movies yet had the rough feel of today's underground music scene.

We started out by photographing a rubber lizard from an angle which made it appear larger than life. Using this photograph as our focal point, we digitally added the three-dimensional type into the mouth of our 'monster.' Once the composite was complete, we added dust and noise to make the image seem as if was created decades ago."

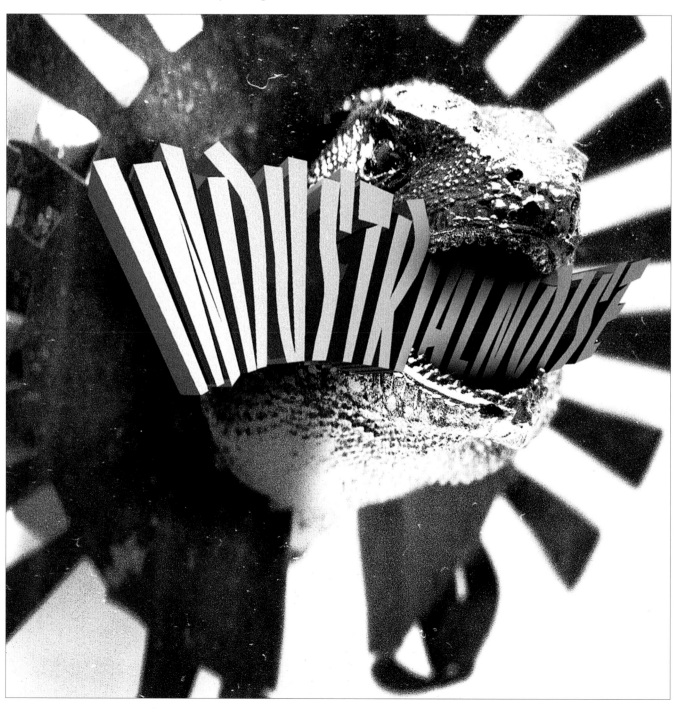

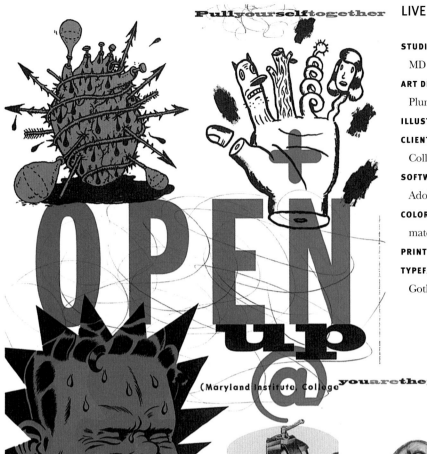

Pull yourself together

OPEN up @

(Maryland Institute, College

youarethepartthatmakesitart

LIVE YOUR VISION POSTER

STUDIO: Spur Design, Baltimore,
MD

ART DIRECTOR/DESIGNER: David
Plunkert

ILLUSTRATOR: David Plunkert

CLIENT/SERVICE: Maryland Institute,
College of Art/art education

SOFTWARE: Adobe Photoshop,
Adobe Illustrator

COLORS: Four, process over two,
match

PRINT RUN: 17,000

TYPEFACES: Cyberotica, Franklin
Gothic Condensed

CONCEPT: "All elements of experi-
ence converge at your eye. The eye
is the conduit and the hand is the
canvas," says designer David
Plunkert. He adds, "Posters that
feature big heads never miss!"

SPECIAL COST-CUTTING TECHNIQUE:
"Mohawk Navajo is an uncoated
stock that has the ink holdout of a
coated sheet—it's nifty."

please post

E-mail
admissions@mica.edu

On the web
http://www.mica.edu

MARYLAND INSTITUTE, COLLEGE OF @rt

410 225 2222 For more information and a catalog
Office of Undergraduate Admission, Maryland Institute, College of Art, 1300 Mount Royal Ave. Baltimore, MD 2I

CATALOG FOR THE 19TH GULBENKIAN FESTIVAL OF CONTEMPORARY MUSIC

STUDIO: Centradesign, Lisbon, Portugal

ART DIRECTOR/DESIGNER: Ricardo Mealha

ILLUSTRATOR: Paulo Scavullo

PHOTOGRAPHER: Pedro Claudio

CLIENT/PRODUCT: Calouste Gulbenkian Foundation/yearly contemporary music festival organized by the Calouste Gulbenkian Foundation Music Department

SOFTWARE: QuarkXPress, Adobe Photoshop, Macromedia FreeHand

COLORS: Four, match

PRINT RUN: 2,000

COST PER UNIT: $10

TYPEFACES: Beowolf (titles), Scala Sans (body)

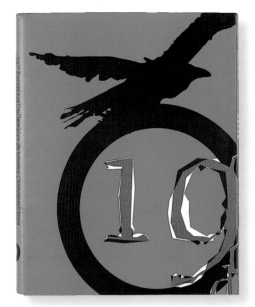

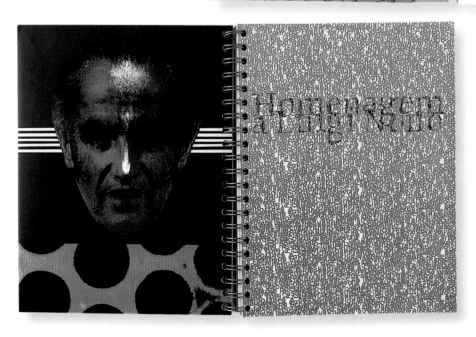

CONCEPT: Designer Ricardo Mealha has this to say about the theme for his design for this music festival catalog: "Since the main musical piece of this festival was 'Prometheus' by the composer Luigi Nono, the picture of the crow on the cover is symbolic of the eagle that in the Greek legend came to Prometheus to eat his liver. The design and colors of the whole catalog follow this theme."

SPECIAL TYPE TECHNIQUES: "Beowolf is an unusual typeface since it always comes out differently each time it's printed, so it's always a surprise," says Mealha. "For example, on the cover of the catalog, since the '19' printed differently on each plate, where '19' on the red plate was supposed to knock out on the green plate, it actually overprinted erratically on a non-specified area."

SPECIAL PRODUCTION TECHNIQUES: "Since the piece was printed in a printing house with very old offset equipment, the results were uncertain, inaccurate and erratic as initially expected."

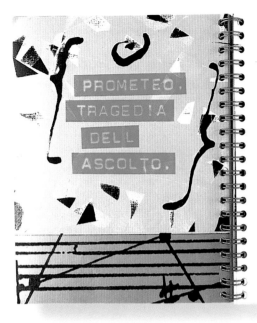

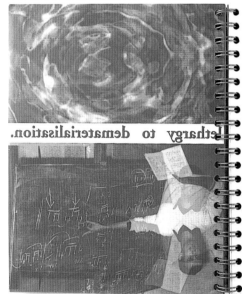

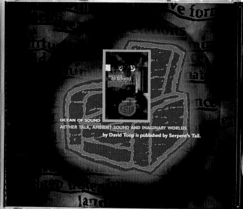

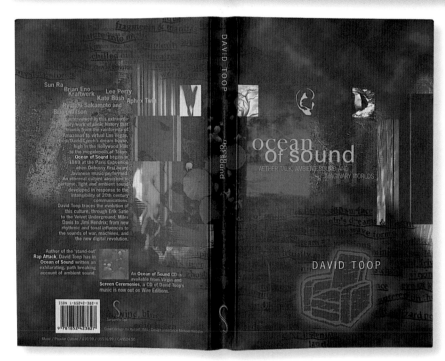

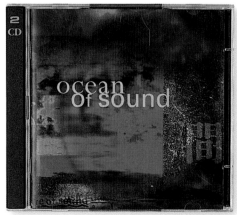

STUDIO NAME: the shed, Ambleside, England; and storm, Ambleside, England

ART DIRECTOR: Russell Mills

DESIGNERS: Russell Mills, Michael Webster

ILLUSTRATOR: Russell Mills

PHOTOGRAPHER: Dave Buckland

CLIENTS/PRODUCTS: Serpents Tail Publisher and Virgin Records Ltd./books and music

SOFTWARE: Adobe Photoshop, Adobe Illustrator, QuarkXPress

COLORS: Four, process

CONCEPT: For this design for a book and accompanying CD about the many forms of ambient music, the goal of designers Russell Mills and Michael Webster was "to show various forms of immersion as metaphor for ambient music."

INSPIRATION: Say Mills and Webster, they were inspired by "the text of the book and the music of the CD" as well as "aspects of ambient music from Debussy to Miles Davis to Brian Eno."

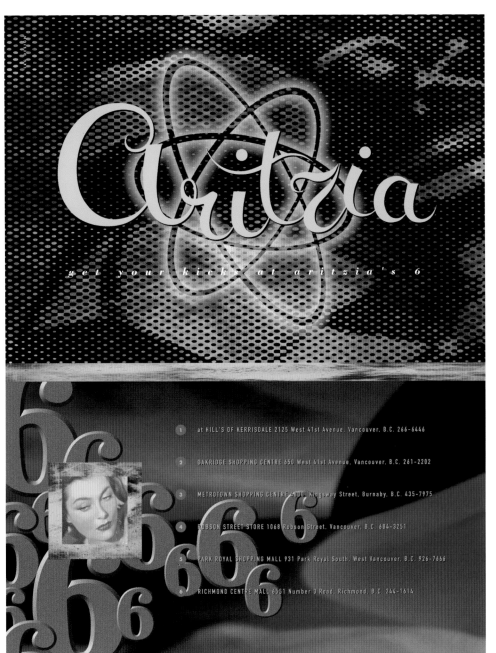

STUDIO/CITY: SRG Design, Los Angeles, CA

ART DIRECTOR/DESIGNER: Steven R. Gilmore

ILLUSTRATOR: Steven R. Gilmore

PHOTOGRAPHER: Found image

CLIENT/SERVICE: Aritzia/clothing store

SOFTWARE: Macromedia FreeHand, Adobe Photoshop, Adobe Dimensions

COLORS: Four, process

TYPEFACES: Trade Gothic (body copy), Bodoni Bold Italic (headline copy), Futura (circle numerals), Cheltenham Bold (the number 6)

CONCEPT: This enigmatic magazine ad gets attention and creates a buzz for clothing store Aritzia.

INSPIRATION: "The lyrics 'Get your kicks on Route 66,' " says Steven Gilmore.

SPECIAL TYPE TECHNIQUES: "I originally created the Aritzia logo with pen and ink; it was then scanned into the computer and used as a template to redraw it in FreeHand."

BHOSS CD

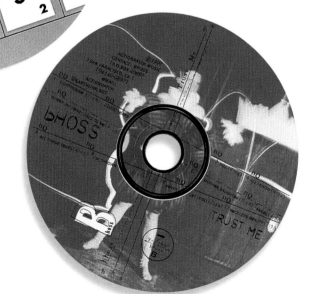

STUDIO: Jennifer Sterling Design, San Francisco, CA

ART DIRECTOR/DESIGNER: Jennifer Sterling

ILLUSTRATOR: Jennifer Sterling

WRITER: Deonne Kahler

CLIENT/SERVICE: bhoss/music

SOFTWARE: Adobe Photoshop, Adobe Illustrator, QuarkXPress, Adobe After Effects

NUMBER OF COLORS: Three over three, match

PRINT RUN: 1,000

COST PER UNIT: $6 US

TYPEFACES: Hand-drawn and various existing

CONCEPT: "The objective was to create an innovative packaging design for the band 'bhoss'," says Jennifer Sterling of this CD packaging. "The packaging is metal die cut on top and bottom and the lyrics are letterpressed (both sides) on coaster stock. Each coaster holds the lyrics to an individual song and depicts the lyrics and musical style of that song."

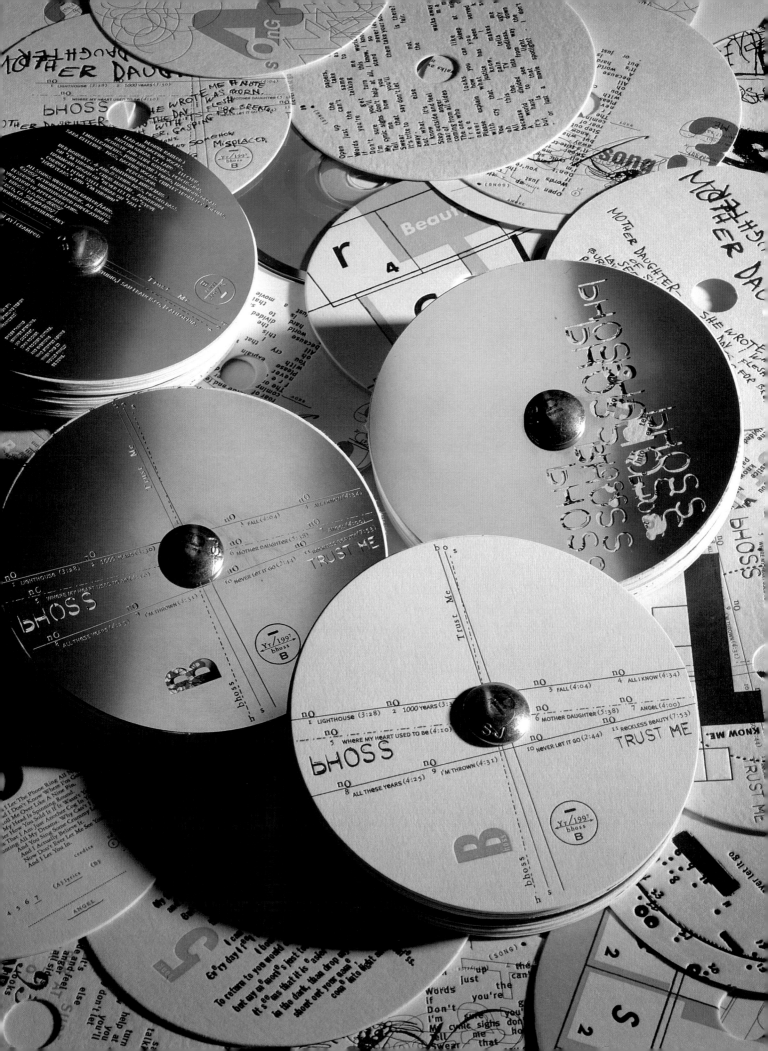

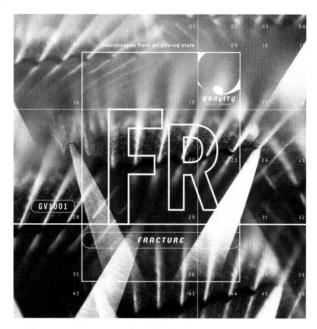

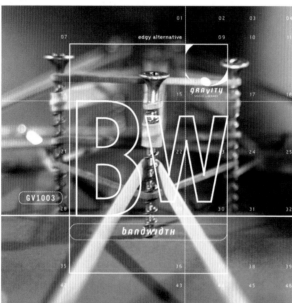

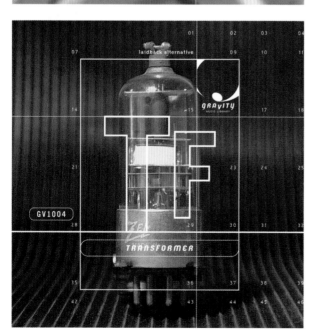

"GRAVITY" MUSIC LIBRARY CD PACKAGING

STUDIO: Kerosene Halo, Chicago, IL

ART DIRECTORS: Thomas Wolfe, Gregory Sylvester

DESIGNER: Thomas Wolfe

PHOTOGRAPHER: Thomas Wolfe

CLIENT/SERVICE: The Burst Collective/Who Did That Music?/custom music and sound design

SOFTWARE: Adobe Illustrator, Adobe Photoshop, QuarkXPress

COLORS: Four, process

PRINT RUN: 5000

TYPEFACES: True (main abbreviation), Udo (product title), Citizen (text)

TYPEFACE DESIGNERS: Kerosene Halo (True), Peter Bruhn (Udo), Zuzana Licko (Citizen)

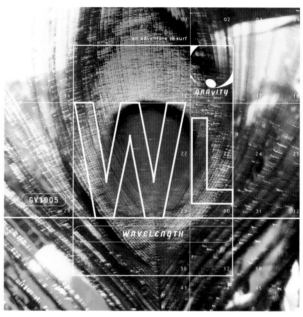

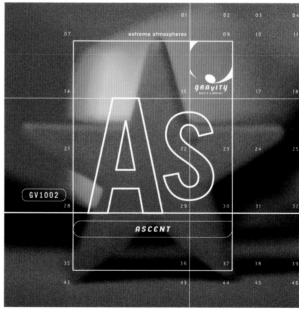

CONCEPT: "Our client approached us needing an identity for a new library of sound effects entitled *Gravity,* " says Thomas Wolfe of Kerosene Halo. "This series was to launch with five releases, but needed a design that would be flexible enough to accommodate up to fifty future releases. They also wanted to title each of the individual releases underneath the *Gravity* umbrella, and had chosen very esoteric names, such as *Fracture, Ascent* and *Wavelength.* The titles and quantity of releases are what led us to the concept of using the periodic table of elements as a basis for the library's identity. We used our own abstract photography to capture the experimental nature of the music, and set the typography in a manner resembling the scientific abbreviation of elements."

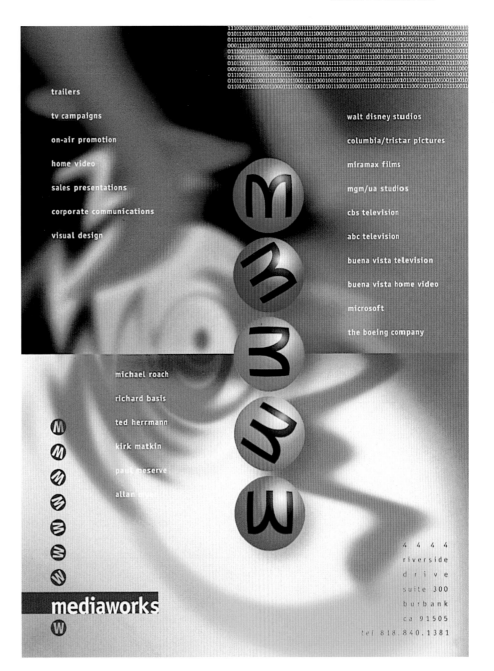

STUDIO: Design Art, Inc., Los Angeles, CA

ART DIRECTOR/DESIGNER: Norman Moore

ILLUSTRATOR: Norman Moore

CLIENT/SERVICE: Media Works/multimedia and film

SOFTWARE: Adobe Photoshop, QuarkXPress

COLORS: Four, process

TYPEFACES: Bundesbann Pi, Officina Sans

CONCEPT: This ad was meant "to give the client's corporate identity a bold, playful and colorful appeal," says designer Norman Moore.

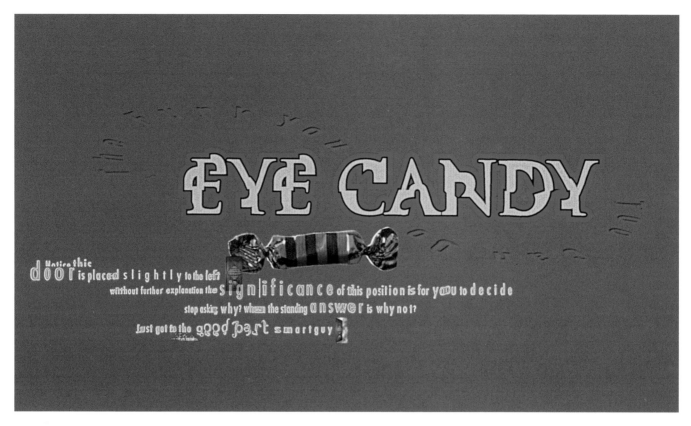

ART DIRECTOR/DESIGNER: Doug
Bartow

ILLUSTRATOR: Doug Bartow

PHOTOGRAPHER: Doug Bartow

CLIENT/SERVICE: Doug
Bartow/design

SOFTWARE: Adobe Photoshop,
Adobe Illustrator, QuarkXPress,
Macromedia Fontographer

TYPEFACE: Eyecandy

TYPEFACE DESIGNER:
Doug Bartow

CONCEPT: "This was in response to a
fellow student's piece hailing the
importance of content over form
in successful design," says Doug
Bartow of this self-promotional
poster. "My view, through this
piece, was that good design uses
form to engage the viewer (and
grasp the content). Content with-
out form is simply literature, but
form without content is simply eye-
candy."

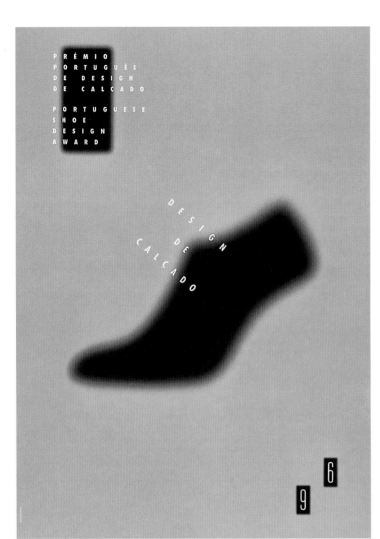

DESIGN DO CALCADO POSTER

STUDIO: João Machado Design, Lda, Porto, Portugal

ART DIRECTOR/DESIGNER: João Machado

ILLUSTRATOR: João Machado

CLIENT/PRODUCT: Centro de Artes de S. João da Madeira/footwear design prize

SOFTWARE: Macromedia FreeHand

COLORS: Two, match

TYPEFACE: Futura Condensed Bold

CONCEPT: This poster promoting a footwear design prize puts its type to work, using type to symbolize shoestrings.

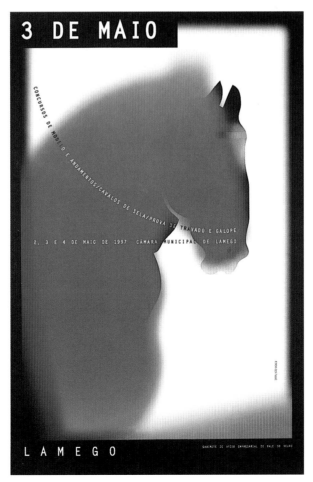

3 DE MAIO POSTER

STUDIO: João Machado Design, Lda, Porto, Portugal

ART DIRECTOR/DESIGNER: João Machado

ILLUSTRATOR: João Machado

CLIENT/SERVICE: Associacao Comercial e Industrial de Lamego/saddle horse fair

SOFTWARE: Macromedia FreeHand

COLORS: Four, process, plus one, match

TYPEFACE: Adagio

CONCEPT: For this poster promoting a saddle horse fair, type is used to symbolize reins.

PROTOTYPE FONT KIT

STUDIO: Automatic Art and Design, Columbus, OH

ART DIRECTOR/DESIGNER: Charles Wilkin

ILLUSTRATOR: Charles Wilkin

CLIENT/SERVICE: Prototype Experimental Foundry/experimental type foundry

SOFTWARE: QuarkXPress, Adobe Photoshop

COLORS: Four, process

PRINT RUN: 2,000

TYPEFACES: Superchunk, Magneto Half Serif, Spaceboy, Dink, Interstate, Velour

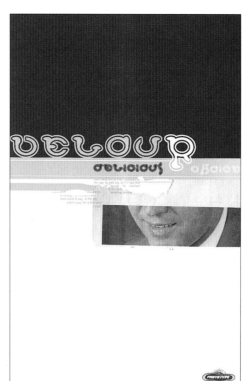

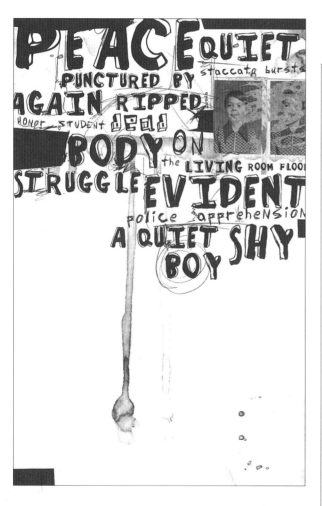

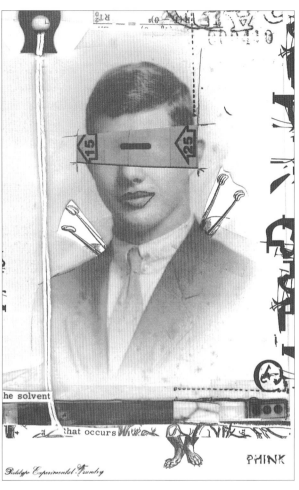

CONCEPT: "The Font Kit was created as a direct mail catalog for Prototype," says Charles Wilkin of this font kit that promotes his own type foundry. "It comes in a 6" × 9" (15cm × 23cm) envelope and contains four 11" × 17" (28cm × 43cm) posters, a few stickers and an 5½" × 8½" (14cm × 22cm) order form. All of the paper and envelopes used are standard sizes and the stickers also double as floppy disk labels. This allows the kit to be easily and inexpensively updated as new fonts are released."

SPECIAL COST-CUTTING TECHNIQUE: The designer's use of standard paper and envelope sizes kept costs down.

CONVERSE GUIDE TO THE URBAN UNDERGROUND

STUDIO: Y Design, New York, NY

ART DIRECTOR/DESIGNER: Martin
Ogolter

CLIENT/PRODUCT: Converse
Canada/sports apparel

SOFTWARE: QuarkXPress, Adobe
Illustrator, Adobe Photoshop

COLORS: Two, match

TYPEFACE: Blur

TYPEFACE DESIGNER: Neville Brody

CONCEPT: Martin Ogolter says that
with this page of listings, he aimed
"to design something that doesn't
have a precious look and feel. I
wanted it to be rough but, even
though the information is unavoid-
ably busy, I wanted the informa-
tion to still be very accessible. The
usage of lines to mimic Japanese
street maps to evoke a certain
order was another idea to bring a
relevant element to the layout."

INSPIRATION: "Cheap supermarket
flyers," says Ogolter.

STUDIO: SRG Design, Los Angeles, CA

ART DIRECTOR/DESIGNER: Steven R. Gilmore

ILLUSTRATOR: Steven R. Gilmore

PHOTOGRAPHER: Anthony Artiaga (background texture)

CLIENT/SERVICE: The Holy Body Tattoo/dance company

SOFTWARE: Macromedia FreeHand, Adobe Photoshop

COLORS: Four, process, with black overprint

PRINT RUN: 4,000

TYPEFACE: Bell Gothic

CONCEPT: According to Steven Gilmore, "This dance performance was originally created in 1994 and relaunched for limited engagements in 1998 to promote the film version of the piece. Because the performance had been updated from its original incarnation, The Holy Body Tattoo thought that the promotional materials should reflect that change. I simply drew from the elements I had designed and illustrated in 1994 for 'Poetry and Apocalypse' and revamped them for 1998."

INSPIRATION: "The 'Sacred Heart'; although I haven't represented the 'Sacred Heart' in a traditional manner, it is the basis for my illustration of the heart motif that has been featured in almost all of The Holy Body Tattoo's promotional materials. Everything that I have done for them revolves around this simple motif and, although it can change on any given project, this motif is probably the most recognizable symbol relating to the company."

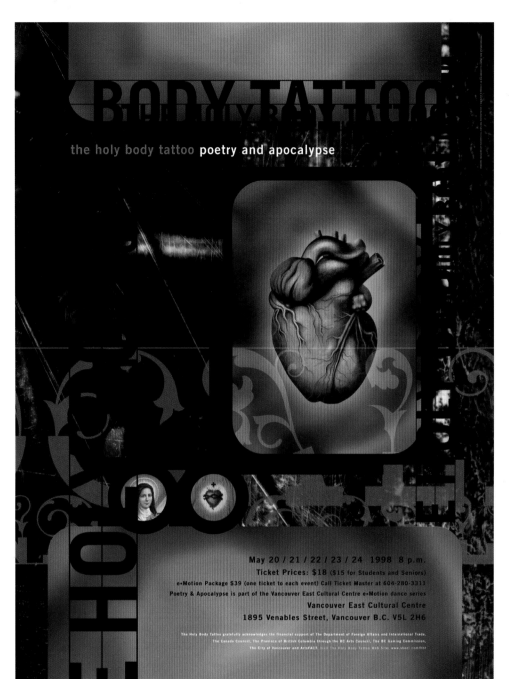

SPECIAL TYPE TECHNIQUES: "The floral typeface ghosted in the background (Heidi) is an original digitally created typeface; although a complete font family was designed, only portions were used for this project."

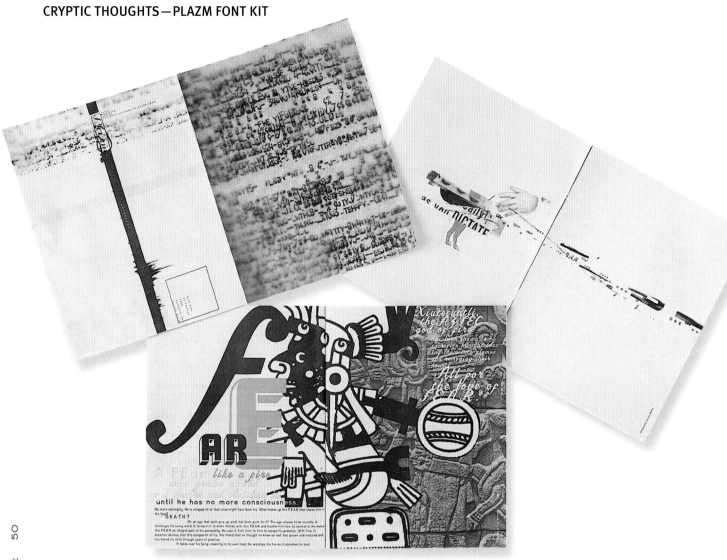

STUDIO: Plazm Media, Inc.,
Portland, OR

ART DIRECTORS: Joshua Berger, Niko
Courtelis, Pete McCracken

DESIGNERS: Pete McCracken, Jon
Raymond, Niko Courtelis, Charles
Wilkin, Pablo Medina, Christian
Küsters, Marcus Burlile, Angus R.
Shamal

CLIENT/SERVICE: Plazmfonts ™ font
foundry

SOFTWARE: QuarkXPress, Adobe
Photoshop, Adobe Illustrator

COLORS: One, black

PRINT RUN: 10,000

COST PER UNIT: $.14 US

TYPEFACES: various

CONCEPT: Here's how Pete McCracken describes the intention behind the design for Plazm's font catalog: "Originally we were researching cryptography and its relationship to typography, reading, and understanding content. As the direction developed, we asked each designer to look inward and graphically describe little darknesses few others see. Our process took us into a esoteric view from the edge. The introduction was inspired by the mystical writings of Pseudo-Dionysius the Areopagite."

SPECIAL TYPE TECHNIQUES: "Type for the cover was created on an IBM Selectric and type for the intro page and center spread was created on a Hermes 3000 (manual)."

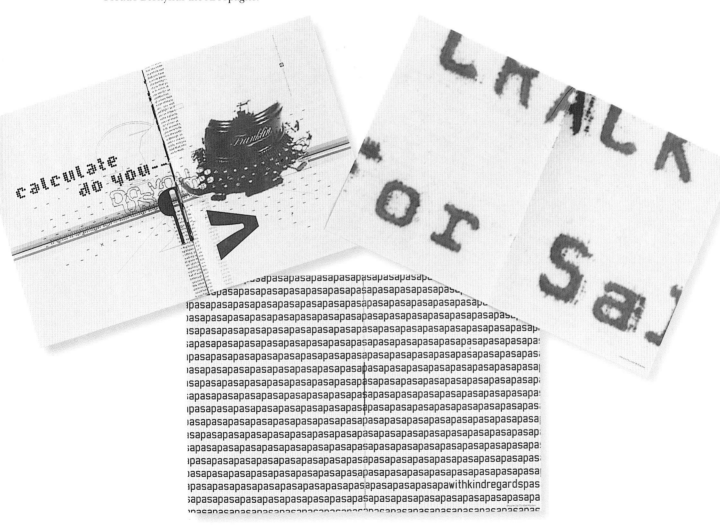

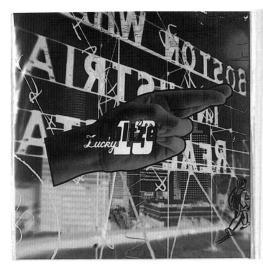
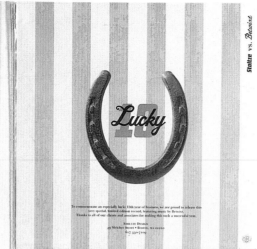
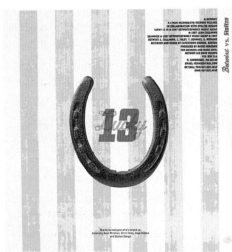
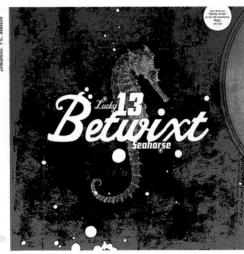

STUDIO: Stoltze Design, Boston, MA

ART DIRECTOR: Clifford Stoltze

DESIGNERS: Clifford Stoltze, Wing Ngan

CLIENT/PRODUCT: Stoltze Design and Betwixt/self-promotional piece and music product

SOFTWARE: QuarkXPress, Adobe Photoshop

COLORS: Two over two, match

PRINT RUN: 1,000

COST PER UNIT: $0.49 (printing only)

TYPEFACES: Futanaltal, New Baskerville, Vitrina

CONCEPT: "The single cover was designed to be reversible—one side to be used by the band Betwixt, the other used to promote Stoltze Design on the occasion of our thirteenth anniversary," says Clifford Stoltze.

SPECIAL COST-CUTTING TECHNIQUES: The piece was printed on the same sheet as another project.

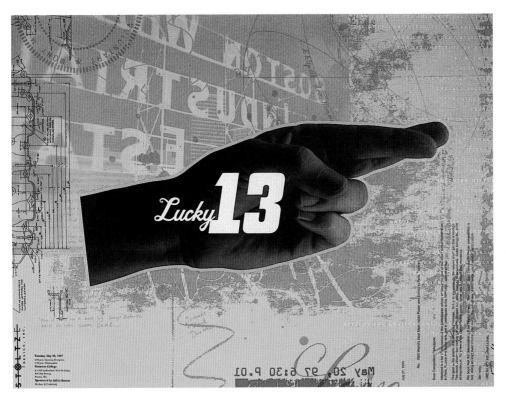

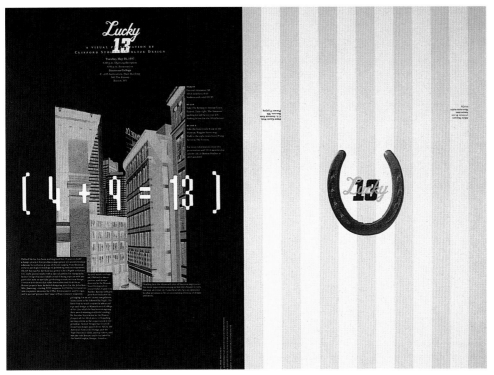

STUDIO: Stoltze Design, Boston, MA

ART DIRECTOR: Clifford Stoltze

DESIGNERS: Clifford Stoltze, Wing Ngan

PHOTOSHOP ILLUSTRATOR: Wing Ngan

CLIENT: AIGA Boston/nonprofit organization servicing the needs of designers

SOFTWARE: QuarkXPress, Adobe Photoshop

COLORS: Four over two, match

PRINT RUN: 2,500

COST PER UNIT: donated

TYPEFACES: Futanaltal, New Baskerville, Vitrina

CONCEPT: "By contrasting simple black and silver design on one side and the layered look of many elements from various designs in orange and chartreuse, we tried to represent the diversity of our work," says Clifford Stoltze of this poster promoting a lecture to mark Stoltze Design's thirteenth year in business.

SPECIAL PRODUCTION TECHNIQUES: The silver overprints black on one side to eliminate the need for traps.

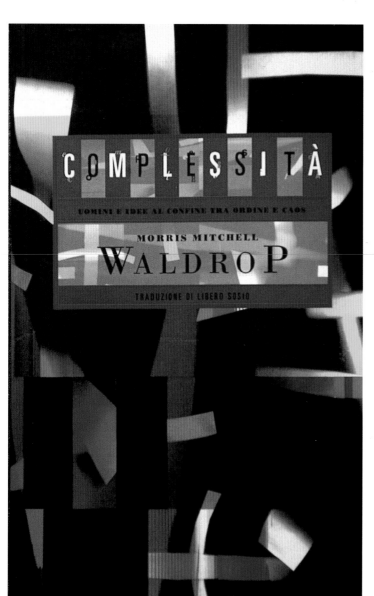

"COMPLESSITA" BOOK JACKET

ART DIRECTOR/DESIGNER/STUDIO: Vaughan Oliver/V23, London, England

ILLUSTRATOR/STUDIO: Russell Mills/the shed, Ambleside, England

PHOTOGRAPHER: Dave Buckland

CLIENT/SERVICE: Instar Libra Publishers, Italy/publishing

COLORS: Four, process

CONCEPT: According to Russell Mills of the shed, both the concept and the inspiration behind this book jacket was chaos theory.

SPECIAL PRODUCTION TECHNIQUES: "One-thousand-watt photoflood lamps shone into Canon 500 laser copier producing visual feedback," says Mills.

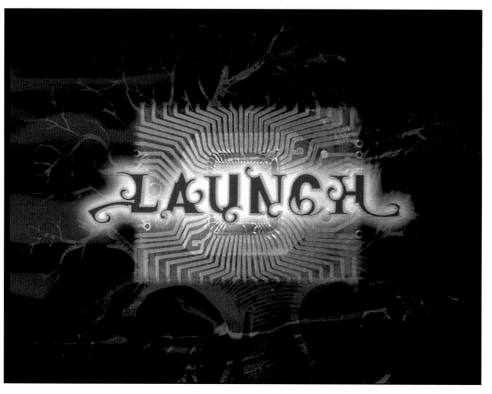

LAUNCH INTERACTIVE SPLASH SCREEN

ART DIRECTOR/DESIGNER: Doug Bartow

CLIENT/SERVICE: Doug Bartow/design

SOFTWARE: Adobe Photoshop, Adobe Illustrator, QuarkXPress, Macromedia Fontographer

TYPEFACE: Trajan (manipulated)

CONCEPT: Doug Bartow describes this piece as "the splash screen to a CD-ROM I created as a part of the graduation requirements for my MFA in graphic design at Cranbrook Academy of Art in Bloomfield Hills, Michigan."

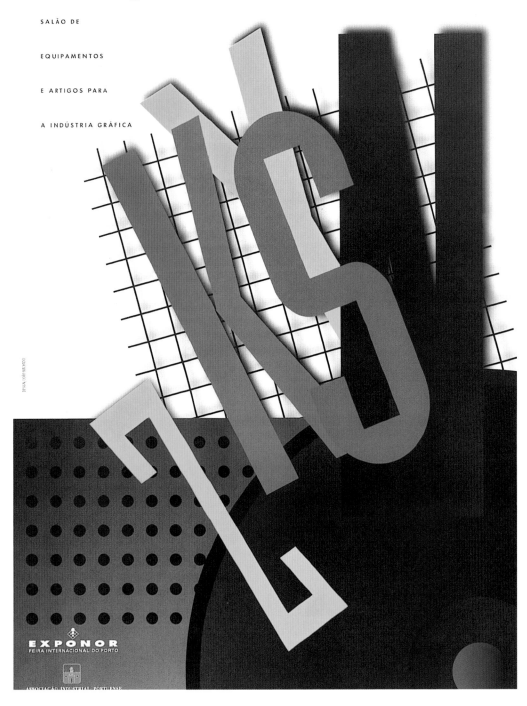

GRAFIKA 96 POSTER

STUDIO: João Machado Design, Lda,
Porto, Portugal

ART DIRECTOR/DESIGNER: João
Machado

ILLUSTRATOR: João Machado

CLIENT/PRODUCT: Associacao
Comercial e Industrial do
Porto/design fair

SOFTWARE: Adobe Photoshop,
Macromedia FreeHand

COLORS: Four, process

TYPEFACE: Courier

CONCEPT: This poster uses a collage
of type to represent the variety of
styles of designs featured at the
design fair it promotes.

SAN FRANCISCO PERFORMANCE SERIES

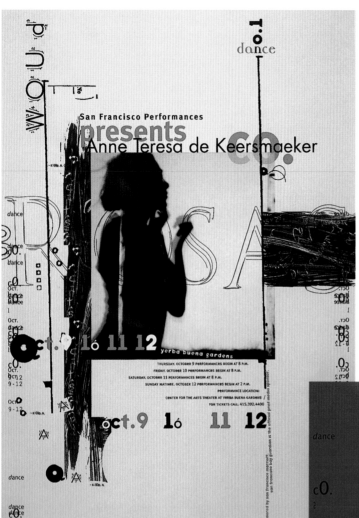

STUDIO: Jennifer Sterling Design, San Francisco, CA

ART DIRECTOR/DESIGNER: Jennifer Sterling

TYPOGRAPHER: Jennifer Sterling

CLIENT/SERVICE: San Francisco Performances/arts and entertainment

SOFTWARE: Adobe Photoshop, Adobe Illustrator, QuarkXPress

COLORS: Two or three, match

PRINT RUN: 65 each

COST PER UNIT: $13.95 US

TYPEFACES: existing and hand-drawn

"ANNE TERESA DE KEERSMAEKER/ROSAS" POSTER REFLECTS A PERFORMANCE OF TIGHTLY KNIT CHOREOGRAPHY COMPRISED OF SHARP, PRECISE, TIGHTLY FOCUSED AND EMOTIONAL MOVEMENTS. THE DANCE IS SHARP, STUDIED, RANDOM AND INTENSE—AT ONCE TIGHTLY, ALMOST PAINFULLY PRECISE WHILE EXCEPTIONALLY PERSONAL AND EMOTIONAL. THE LARGE PHOTO REPRESENTS THE LIVE VIDEO THAT IS PROJECTED THROUGHOUT THE PERFORMANCE AND FILLS THE ENTIRE STAGE WHILE THE PERFORMANCE CONTINUES."

"DV8 PHYSICAL THEATRE IS AN EXPLOSIVELY FRANK DANCE THAT EXPLORES ISSUES OF CONTEMPORARY ALTERNATIVE MASCULINITY. THE STAGE IS PROPPED WITH HARD AND INDUSTRIAL ELEMENTS WHICH THE PERFORMERS INCORPORATE IN THE CHOREOGRAPHY."

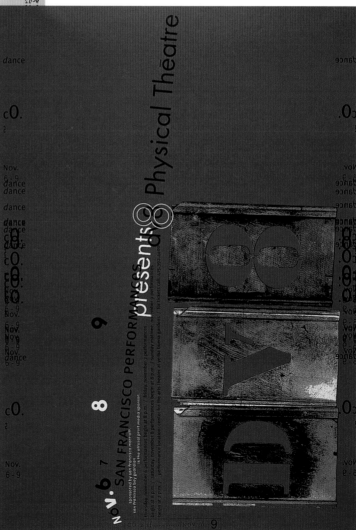

CONCEPT: Of the performance series she designed these posters and bus shelter ads for, Jennifer Sterling says that "the series and performances feature quite different elements of dance, and the individual posters needed to reflect the works of these various dance companies. The companies had little or no photography to work with (compounded by a limited budget), so the typography became responsible for evoking the dance or experience of each performance."

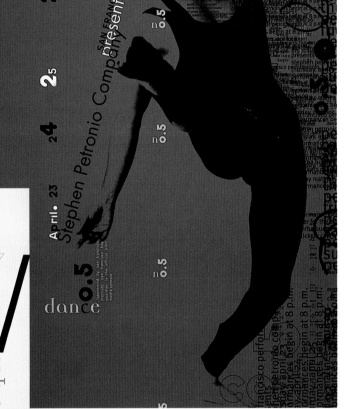

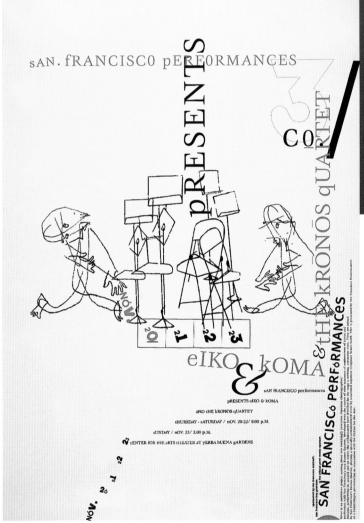

"THE TWO PERFORMERS, EIKO AND KOMA, ARE PRAISED FOR THEIR MASTERY OF STILLNESS AND MOVEMENT. THEIR PERFORMANCES SEEM TO BE A SERIES OF INCREDIBLY STILL CONTORTIONS. THE KRONOS QUARTET BACKS THIS INTRICATE PERFORMANCE."

"IN CREATING THE STEPHEN PETRONIO POSTERS, WE TRIED TO CONVEY HIS STYLE OF CHOREOGRAPHY. STEPHEN IS CONSIDERED ONE OF THE MOST FEARLESSLY INVENTIVE CHOREOGRAPHERS OF HIS GENERATION; HIS COMBINATION OF ELEMENTS AND OVERLAP ARE REFLECTED IN THE BOLD WAY IN WHICH HE PERFORMS."

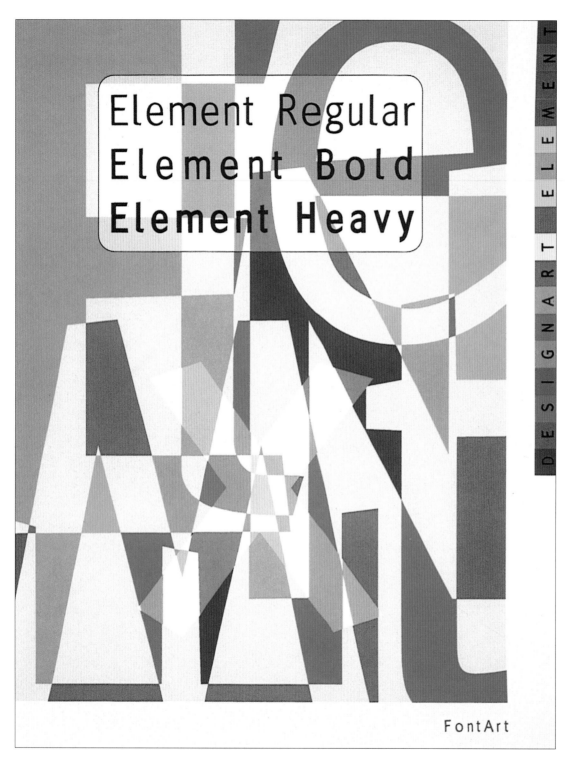

STUDIO: Design Art, Inc., Los
Angeles, CA

ART DIRECTOR/DESIGNER: Norman
Moore

CLIENT/SERVICE: Design Art,
Inc./design studio

SOFTWARE: Macromedia
Fontographer

TYPEFACE: Element

TYPEFACE DESIGNER: Norman Moore

CONCEPT: This self-promotion poster
highlights Norman Moore's font
Element.

STUDIO: SRG Design, Los Angeles, CA

ART DIRECTOR/DESIGNER: Steven R. Gilmore

ILLUSTRATORS: Paolo Venturi, Steven R. Gilmore

CLIENT/SERVICE: Motown Records/record label

SOFTWARE: Macromedia FreeHand, Adobe Photoshop

COLORS: Four, process

TYPEFACES: Helvetica (main title), Comos Extra Bold (smaller type), Bodoni (numerals)

CONCEPT: "This series of CDs features reissues of the funkier tracks of Motown's back catalog," says Steven Gilmore. "I approached the design of this series inspired by a combination of Blaxsploitation film posters of the 1960s and 1970s, pinup art of the 1950s, and modern-day club flyers. Because so much of this music is currently being played in clubs or sampled by recording artists, I thought it was important to convey a modern sensibility while making sure the roots of the original time period were still in place."

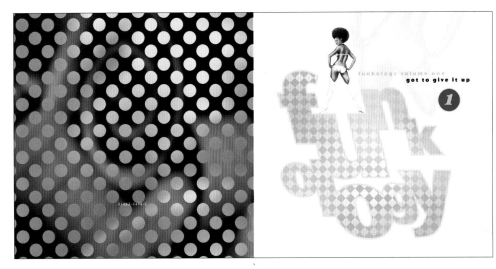

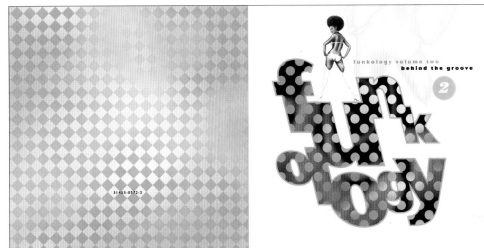

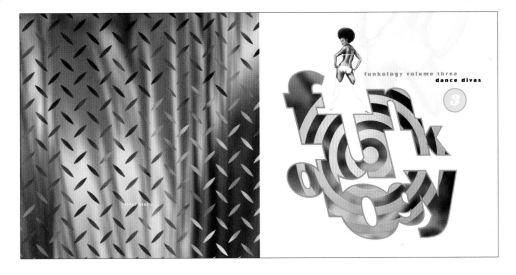

"PICCOLO APPELLO AL MONDO DELLA CULTURA"

STUDIO: The Looking Glass Factory, Rome, Italy

ART DIRECTOR/DESIGNER: Massimo Kunstler

CLIENT/PRODUCT: *Derive Approdi/*magazine

SOFTWARE: QuarkXPress, Adobe Photoshop

COLORS: Four, process

PRINT RUN: 3,000 copies

COST PER UNIT: L. 8.000 (approx. $5 US)

TYPEFACES: various

CONCEPT: According to Massimo Kunstler, the idea behind this layout of a poem in *Derive Approdi* was "futurism revisited".

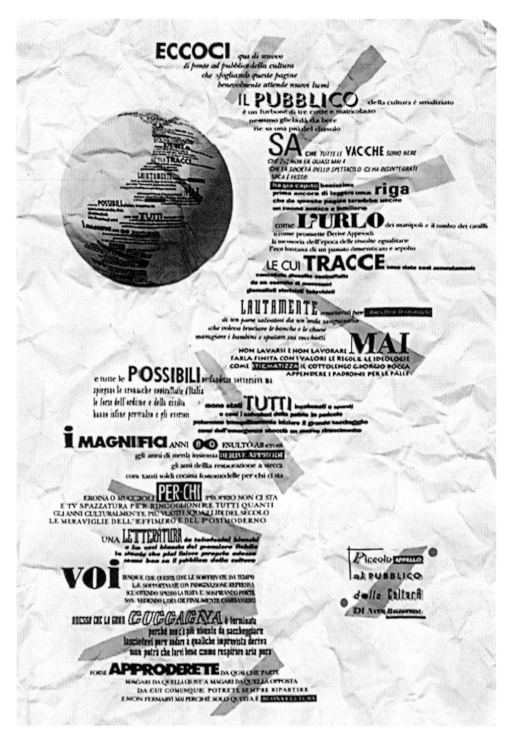

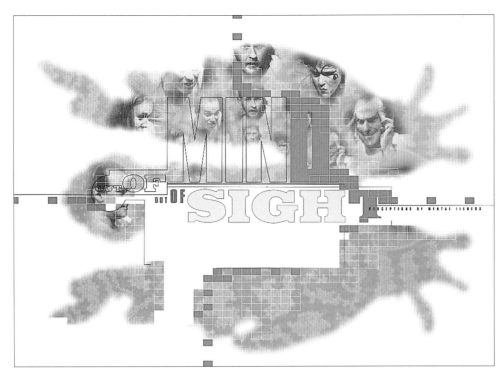

OUT OF MIND, OUT OF SIGHT BROCHURE

STUDIO: Eg.G, Sheffield, England

ART DIRECTOR/DESIGNER: Dom Raban

CLIENT/SERVICE: Centre For Psychotherapeutic Studies/educational institution

SOFTWARE: Adobe Illustrator, Adobe Photoshop

COLORS: Four, process, plus one, match

PRINT RUN: 1,000

COST PER UNIT: £3 UK

TYPEFACES: Trade Gothic, Compacta, Egypto Heavy

CONCEPT: "The well-known Rorschach inkblot test provided inspiration for this design, which is the cover of a report about an arts festival examining issues of mental illness," says Dom Raban of Eg.G. "The client provided a number of stills of people involved in the festival. Using repeated images of just their heads and a background pattern of brain tissue, we created a disturbing image that is contained within a Rorschach-type shape. The broken type further empha-sizes the connection with mental illness."

SPECIAL TYPE TECHNIQUES: The type was digitally manipulated in Adobe Illustrator.

21st-century classics

section THREE

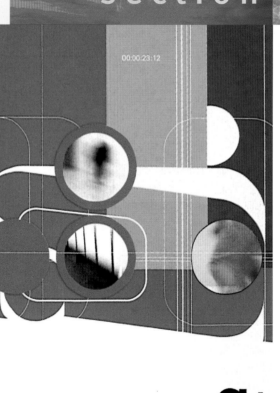

00:00:23:10 00:00:23:11 00:00:23:12

FUNDAÇÃO CALOUSTE GULBENKIAN ac**a**rte

ENCONTROS

ACARTE

CO

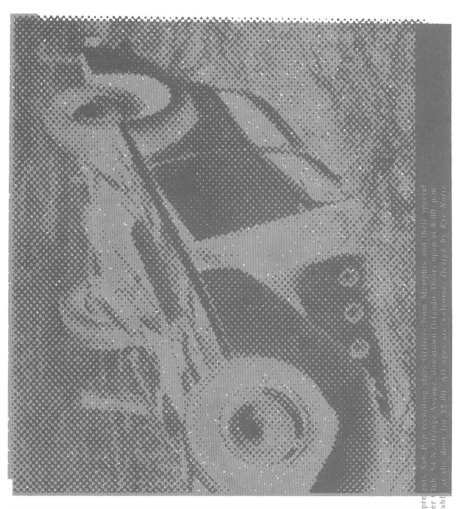

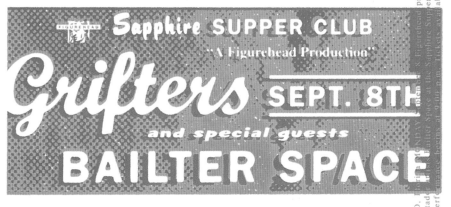

GRIFTERS CONCERT POSTER

STUDIO: Eye Noise, Orlando, FL

DESIGNER: Thomas Scott

CLIENT/SERVICE: Figurehead/concert promoter

SOFTWARE: Adobe Illustrator, Adobe Photoshop

COLORS: Two, match

PRINT RUN: 65

COST PER UNIT: $3.85 US

TYPEFACES: Houston, Franklin Gothic, Bold Script 332, Boris, Times Roman

TYPEFACE DESIGNERS: Victor Lardent and Stanley Morison (Times Roman), Morris Fuller Benton (Franklin Gothic)

CONCEPT: Thomas Scott explains his design for this Grifters concert poster by saying that "Grifters in concert can sound like a car wreck. The old car wreck photo was turned on its side and crashes into the type."

INSPIRATION: "I had seen the Grifters perform terrific, sloppy shows previously."

SPECIAL TYPE TECHNIQUES: "Photoshop filters helped to achieve a worn-out and distorted look."

SPECIAL PRODUCTION TECHNIQUES: Screen printing

BRONZE IRON & PAPER INVITATION

STUDIO: Slip Studios, Chicago, IL

DESIGNER: Stephen Farrell

SCULPTURE PHOTOGRAPHER: David Haj-Abed (sculpture by Dervella McNee)

CLIENT/SERVICE: Artists' Liason ATC Gallery/gallery

SOFTWARE: QuarkXPress, Adobe Illustrator, Adobe Photoshop

NUMBER OF COLORS: One, black

PRINT RUN: 2,000

TYPEFACE: Eurostile Extended, Colossalis, Engravers Bold Face

CONCEPT: "What more potent contrast than the mediums of iron and paper?" asks Stephen Farrell. "My initial meetings with iron sculptor Dervella McNee inspired an aesthetic of muscular fluidity for this gallery card. We constructed both gallery space and gallery card around this notion of weighted space, of the lightness of being heavy."

SPECIAL TYPE TECHNIQUES: "I digitally manipulated Colossalis to imitate recurring motifs in the iron sculpture."

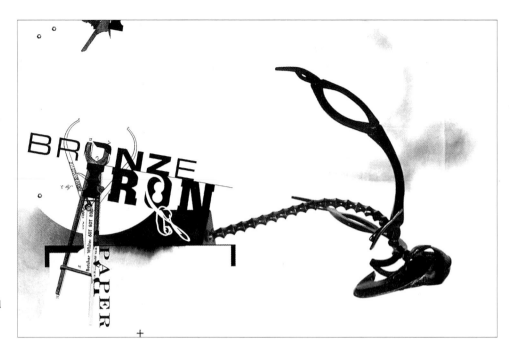

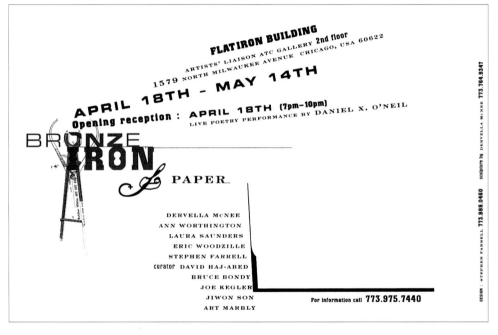

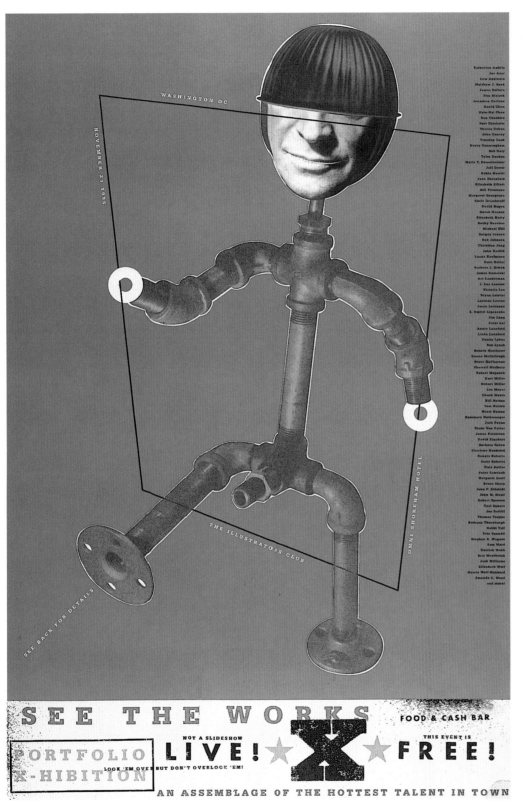

STUDIO: Spur, Baltimore, MD

ART DIRECTOR/DESIGNER: David Plunkert

ILLUSTRATORS: Dr. Barry Walters, David Plunkert

PHOTOGRAPHER: David Plunkert

CLIENT/SERVICE: Illustrators Club of Metropolitan Washington/creative association

SOFTWARE: Adobe Illustrator, Adobe Photoshop

COLORS: Four, match

PRINT RUN: 5,000

TYPEFACES: Scrifa, Franklin Gothic Condensed

CONCEPT: David Plunkert says that the central figure of this poster "represents an assemblage of talent; his full frontal nudity represents exhibition."

INSPIRATION: "The plumbing figure 'Mr. Pipey' was created by Dr. Barry Walters when he was a child," says Plunkert. "I saw it in his father's hardware store window and had a copy made for the poster."

SPECIAL TYPE TECHNIQUE: Fonts were distressed with a photocopier and scanned in as monotones in Photoshop.

CHOOSE ONE SELF-PROMOTION

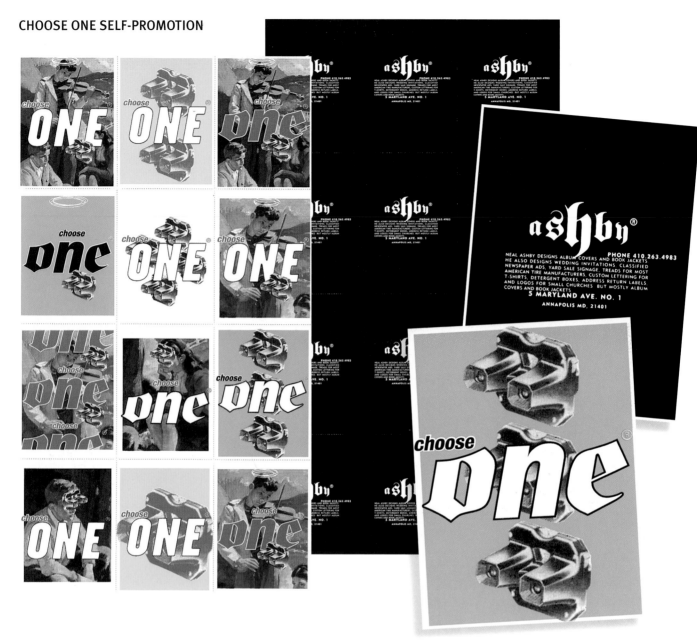

STUDIO: Ashby Design, Washington DC

ART DIRECTOR/DESIGNER: Neal Ashby

ILLUSTRATOR: Neal Ashby

CLIENT/SERVICE: Ashby Design/design studio

SOFTWARE: QuarkXPress, Adobe Photoshop, Adobe Illustrator

NUMBER OF COLORS: Four, process plus one, match

PRINT RUN: 5,000

COST PER UNIT: $.20

TYPEFACES: Fraktur, Futura, Bureau Grotesque

CONCEPT: "I just wanted to design something for myself with no limits, something that meant something personal to me," says Neal Ashby of these business cards he designed for himself. "I liked the idea of the juxtaposition of very commercial-looking type against an old illustration. It clashed in just the right way. I designed about ten posters, thinking I was going to silkscreen them for myself. But I couldn't decide on one poster, because they all looked good *together*. So I made them business cards instead and printed all of them."

SPECIAL TYPE TECHNIQUES: "The words 'choose one' were taken into Illustrator and given an outline of either white or black so as to show up against the illustration."

SPECIAL PRODUCTION TECHNIQUES: "Using fluorescent green and process yellow by itself to create a glowing effect."

SPECIAL COST-CUTTING TECHNIQUES: "Used a low grade card stock originally intended for baseball cards."

STUDIO: REY International, Los Angeles, CA

ART DIRECTOR/COMPANY: Jeff Fey/Capitol Records

DESIGNER/STUDIO: Greg Lindy/REY International

CLIENT/SERVICE: Capitol Records, Inc./record company

SOFTWARE: QuarkXPress, Adobe Photoshop, Macromedia FreeHand

COLORS: Three, match

PRINT RUN: 5,000

COST PER UNIT: $.25 US

TYPEFACES: Alternate Gothic, Futura, Siggi, Vag

TYPEFACE DESIGNER: Roger Gurbani (Siggi)

CONCEPT: Greg Lindy says that this postcard announcing concert appearance of Capitol acts at the South by Southwest convention "plays off on the typical 'Western' themes and puts an unusual spin on them. The piece was to evoke interest and on some levels humor."

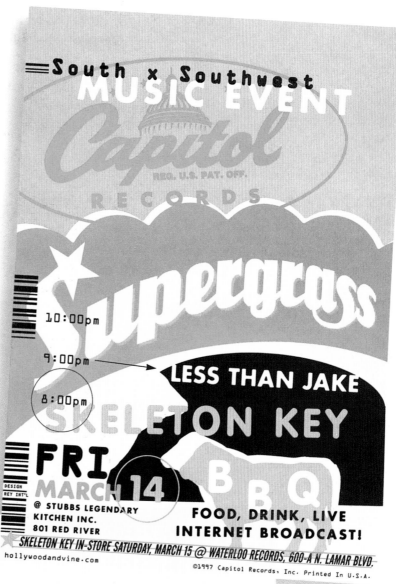

CATALOG FOR THE 1997 ACARTE FESTIVAL

STUDIO: Centradesign, Lisbon, Portugal

ART DIRECTOR: Ricardo Mealha

DESIGNER: Carlos Rei

ILLUSTRATOR: Carlos Rei

CLIENT/SERVICE: Calouste Gulbenkian Foundation/yearly dance-performance-workshop festival

SOFTWARE: QuarkXPress, Adobe Photoshop, Macromedia FreeHand

COLORS: Four, process, plus one, match (cover); two, match (interior)

PRINT RUN: 1,000

COST PER UNIT: $5 US

TYPEFACE: Helvetica Neue

CONCEPT: Designer Ricardo Mealha's goal when creating this catalog for a dance-performance festival was "to create a graphic language that translated the different shows of the festival to paper."

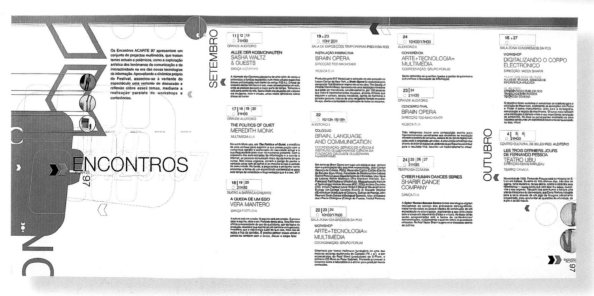

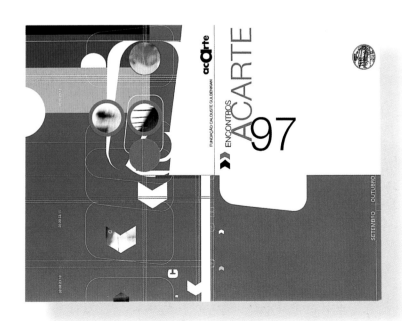

VOLGARE PROCLAMATION

STUDIO: Slip Studios/The Mss Folio,
Chicago, IL

DESIGNER: Stephen Farrell

WRITER: Daniel X. O'Neil

SOFTWARE: Macromedia
Fontographer, Adobe Illustrator,
Adobe Photoshop, QuarkXPress

COLORS: One, black

PRINT RUN: 1,000

TYPEFACES: Volgare (primary text),
Barbera

TYPEFACE DESIGNER: Stephen Farrell
(Volgare), Peter Bruhn (Barbera)

CONCEPT: "The Mss Folio is a digital foundry dedicated to fonts derived from European documentary cursive. Documentary cursive was the formalized handwriting style adopted by the rapidly expanding merchant class for commercial and legal writing from the end of the Renaissance. The first face, Volgare, was inspired by a hand from 1601, Florence. I came across the original manuscript, a death record, at the Newberry Library in Chicago and similar ones in Florence and Palermo. Its author, an anonymous clerk we call, was performing a simple act that is one hallmark of a civilized society: Every time someone died, he added the name of that person, and the day that person died, and the neighborhood that person lived in, to a list. I have cobbled together singular scratches and penstrokes of to include over 500 characters in the Volgare family. Variations of each letterform allow for a more convincing simulation of the varied marks of actual handwriting.

"The Mss Folio project begs the question: What does it mean to place handwriting outside the act of its creation? Our handwriting marks a here and now. The act seems to pass through the hand unaware of itself, unaware of its origins. Handwriting's topology portrays waves of vigor and fatigue, irregularity, attentiveness and daydream: traces of the corporeality of a living hand. As we codify these traces within a digital context, we activate the ability to atomize the surface of the private and replicate it ad infinitum—spread it across the public—not only for mass consumption but also as apparatus for production, for (re)tracing. What becomes then of human physicality, of the markings of individuality?

"The letter, drawn in ink, is not permanent; it is organic, kinetic. It bleeds and fades. The digital medium offers to a handwriting performance its eternal return. Each keystroke (re)produces a frozen placard pointing to its originary act. It couples a moment—an infinitely particular context—with the ability to replay that moment in perfect similitude in all places. The living hand leaves the encumbrances of corporeality. Its movements explode outward in packaged bits of a ritual to be shared by all. As we enter into a manipulation of this private sphere of writing, we slip through voyeurism into another's hand as glove—invasive yet anonymous."

STUDIO: Massachusetts Museum of
Contemporary Art (MASS MoCA),
North Adams, MA

ART DIRECTOR/DESIGNER: Doug
Bartow

ILLUSTRATOR: David Byrne

PHOTOGRAPHER: David Byrne

CLIENT/SERVICE: Massachusetts
Museum of Contemporary Art
(MASS MoCA)/museum

SOFTWARE: Adobe Photoshop,
Adobe Illustrator, QuarkXPress

NUMBER OF COLORS: Four, process
plus one, metallic

PRINT RUN: 10,000

TYPEFACE: Bitstream Futura, VAG
Rounded

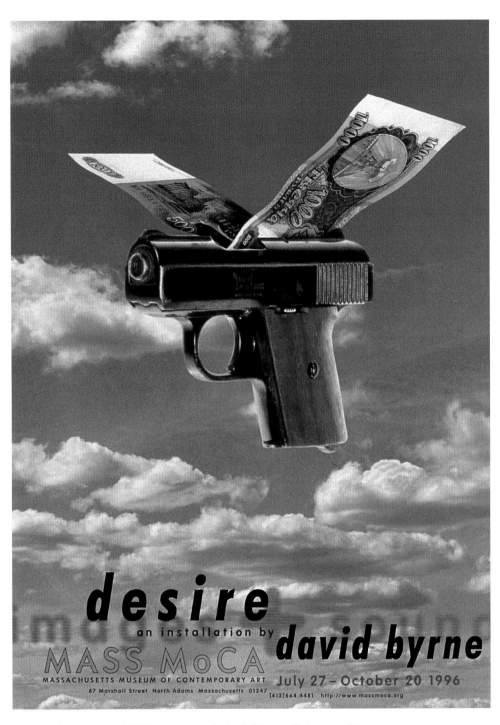

CONCEPT: "As in most exhibition announcement, reverence must be given when actual art is being used as image," says Bartow of this poster he designed promoting an exhibit called "Desire," a collection of art done by David Byrne, formerly of the Talking Heads. "I tried to infringe as little as possible on Byrne's gun image, while at the same time trying to transform the singular image into an informational piece of design."

SPECIAL COST-CUTTING TECHNIQUES: "Get a big printer to underwrite a major exhibition," says Bartow.

TOP TEN FACT BOOK BROCHURE

STUDIO: Recording Industry Association of America, Washington DC

ART DIRECTOR/DESIGNER: Neal Ashby

ILLUSTRATOR: Neal Ashby

PHOTOGRAPHERS: various

CLIENT/SERVICE: Recording Industry Association of America/trade group representing the major American record labels

SOFTWARE: QuarkXPress, Adobe Photoshop, Adobe Illustrator

COLORS: Three over three, match

PRINT RUN: 8,000

COST PER UNIT: $1 US

TYPEFACES: Champion, Ziggurat, Saracen, Village

TYPEFACE DESIGNER: Jonathan Hoeffler (Saracen)

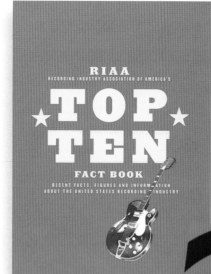

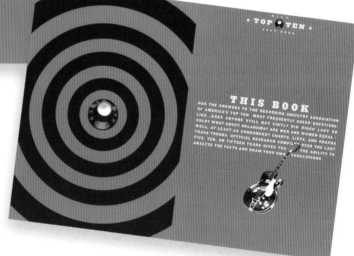

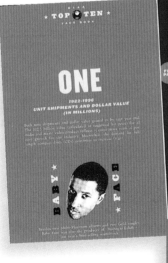

CONCEPT: "We wanted to create a relatively inexpensive music statistic booklet," Neal Ashby says of this brochure done for the Recording Industry Association of America. "I knew I would only have two or three colors, and no money for illustrations and photography, so the challenge was on. The illustrations for the instruments and amplifier knobs came from music catalogs from the 1960s. The photos for the artists came from the record labels and promotional departments of the recording artists, and are coincidentally copyright free."

SPECIAL PRODUCTION TECHNIQUES: "Some charts were too big for the 6" x9" (15cm x 23cm) format, so we had some pages that flip out."

SPECIAL COST-CUTTING TECHNIQUES: Copyright-free images and only three colors were used.

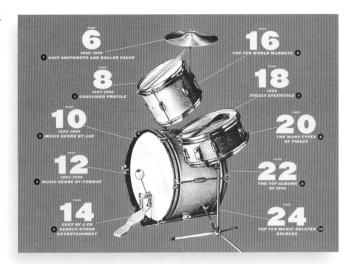

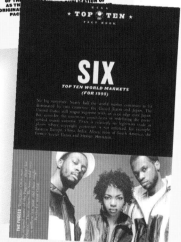

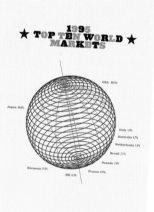

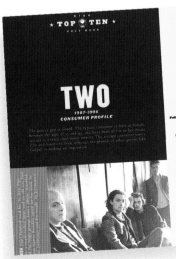

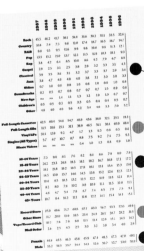

JOHN CALE CONCERT POSTER

STUDIO: Eye Noise, Orlando, FL

DESIGNER: Thomas Scott

CLIENT/SERVICE: Figurehead/concert promoter

SOFTWARE: Adobe Illustrator, Adobe Photoshop

COLORS: Two, match

PRINT RUN: 265

COST PER UNIT: $2.35

TYPEFACES: Geometric Slab (head), Franklin Gothic, Akzidenz Grotesk, Latiara, Latin Extra Condensed

TYPEFACE DESIGNERS: Morris Fuller Benton (Franklin Gothic), Hermann Berthold (Akzidenz Grotesk)

CONCEPT: "John Cale is a highly regarded and influential figure in the music world," says designer Thomas Scott. "This was a rare American club tour in which Mr. Cale fronted a rock band. As I am a longtime fan of his music, the design is a tribute to his genius and an irreverent stab at his seriousness. All the information is crowded together in an eccentric Victorian fashion and slapped over the eyes of Mr. Cale's very unflattering publicity photo—all of which is superimposed over old engravings of locusts, which combine together to make Mr. Cale into sort of a monster. The heraldic symbols of Great Britain and the Prince of Wales were included as a joke (Mr. Cale is Welsh)."

INSPIRATION: "Mr. Cale's eccentric personality, and the title of his then most recent recording, 'Walking On Locusts.'"

SPECIAL PRODUCTION TECHNIQUES: "Screen printing on a linen stock was very successful in holding detail."

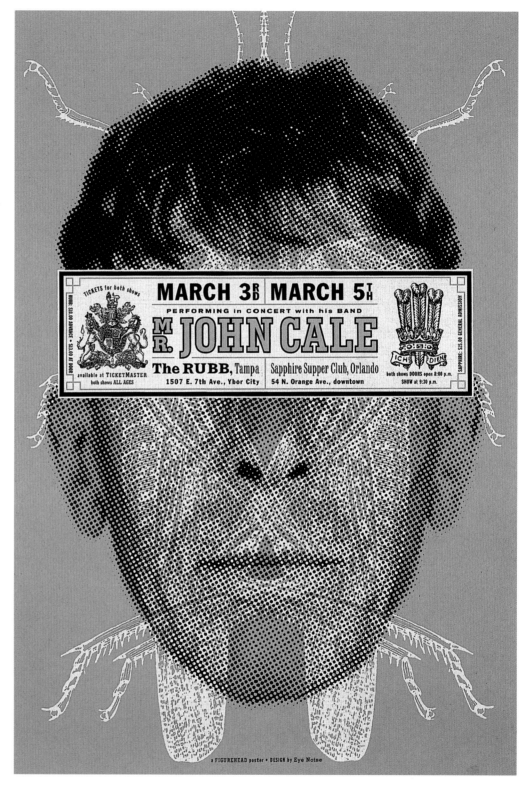

STUDIO: Melinda Beck Studio, New York, NY

ART DIRECTOR/DESIGNER: Melinda Beck

ILLUSTRATOR: Melinda Beck

TYPOGRAPHER: Melinda Beck

CLIENT/SERVICE: American Institute of Graphic Arts, Washington DC Chapter/graphic design organization

SOFTWARE: QuarkXPress, Adobe Illustrator, Adobe Photoshop

COLORS: Four, process

TYPEFACES: Freehand, Craw, Rockwell, Franklin Gothic

CONCEPT: "This design communicated the whimsy and fun of the event it advertised," Melinda Beck says of this invitation to an AIGA event.

INSPIRATION: "I wanted to create a design with a whimsical look like an oversized children's book."

SPECIAL TYPE TECHNIQUES: "The typefaces were created using India ink and cut paper."

SPECIAL PRODUCTION TECHNIQUES: The design was created by combining digital art and handwork.

SPECIAL COST-CUTTING TECHNIQUES: "There was no budget for illustration or photography so I created the illustration myself and used stock photography," says Beck.

"GUIDEBOOK FOR PUBLISHING PHILOSOPHY" COVER

STUDIO: Todd Childers Graphic Design, Bowling Green, OH

ART DIRECTOR/DESIGNER: Todd Childers

PHOTOGRAPHER: Todd Childers

CLIENT/SERVICE: Philosophy Documentation Center, Bowling Green State University/philosophy-related reference materials

SOFTWARE: Adobe Photoshop, Adobe Illustrator, Macromedia Fontographer

COLORS: Two, match

PRINT RUN: 1,000 (first printing), 500 (second printing)

COST PER UNIT: $4.57 US

TYPEFACES: ITC New Baskerville, OCR B

CONCEPT: Todd Childers says his intent when designing this book cover was "to update Baskerville's typography with digital imagery and decorative devices."

INSPIRATION: "John Baskerville's books," says Childers.

SPECIAL TYPE TECHNIQUES: "Altered New Baskerville in Fontographer by making the fine strokes thinner to look more like the original Baskerville."

SPECIAL PRODUCTION TECHNIQUES: Adobe Illustrator 3-D filters.

SPECIAL COST-CUTTING TECHNIQUES: The use of duotones kept costs low.

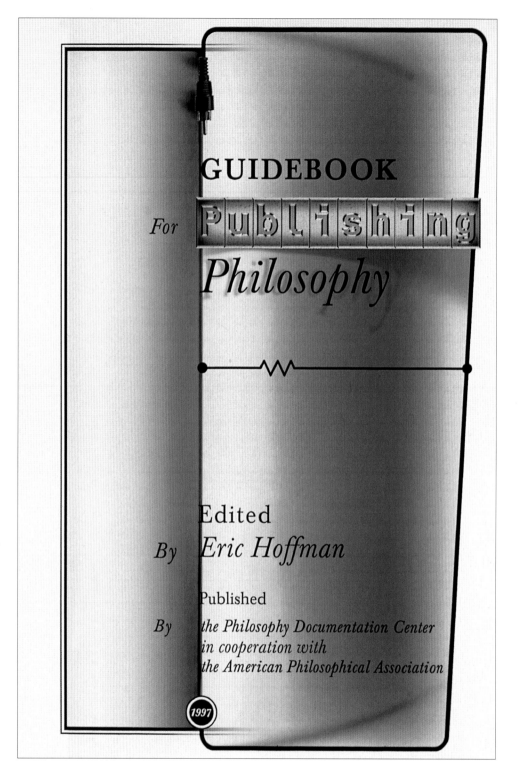

MYTHOPOEIA

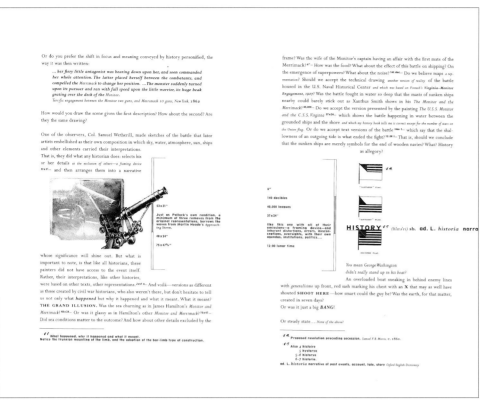

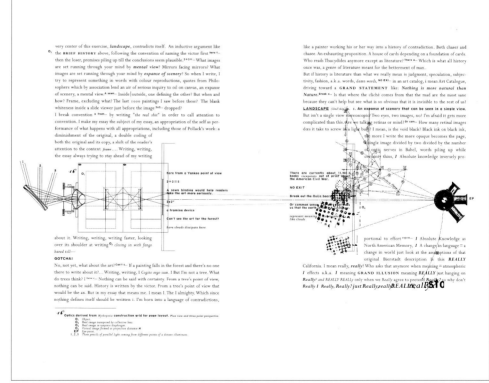

STUDIO: Slip Studios, Chicago, IL

DESIGNER: Stephen Farrell

COLLABORATORS: Stephen Farrell, Don Pollack, Steve Tomasula

ILLUSTRATOR: Stephen Farrell (inspired by various historical engravings)

WRITER: Steve Tomasula

SOFTWARE: QuarkXPress, Adobe Illustrator, Adobe Photoshop, Macromedia Fontographer

COLORS: One, black

PRINT RUN: 250

TYPEFACES: Perpetua (body copy), Spartan Classified (headings, footnotes), Caslon 3 small caps, Volgare (various quotes)

TYPEFACE DESIGNERS: Eric Gill (Perpetua), Stephen Farrell (Volgare)

CONCEPT: Stephen Farrell says about this piece: "Mythopoeia is a three-way collaboration (writer Steve Tomasula, painter Don Pollack and myself) which originally served as a companion piece to Don Pollack's painting show in Atlanta. The piece is at once an art catalog and a critique of the art catalog. Its text questions a text's ability to encapsulate a body of painting without producing something quite apart from it, without subjecting its subject to a transformative process, a mythopoeia. The writing intentionally supplants the paintings (no paintings are shown until the last few pages) while the visual narrative recontextualizes or manufactures 'historical' images. Both text and image spiral into self-reflexivity as the catalog dissolves into its own metalanguage. The book halts its own dismantling with a series of white pages (reintroducing the book as landscape), followed by pages of actual penciled sketches (reintroducing the original mark) and, eventually, reproductions of paintings and a reintroduction of text."

GAINESVILLE JAZZ POP FESTIVAL POSTER

STUDIO: Eye Noise, Orlando, FL

DESIGNER: Thomas Scott

CLIENT/SERVICE: Gainesville Jazz Pop Festival/music festival

SOFTWARE: Adobe Illustrator, Adobe Photoshop

COLORS: Three, match

PRINT RUN: 165

COST PER UNIT: $5 US

TYPEFACES: Franklin Gothic, Huxley Vertical (redrawn and very distorted)

TYPEFACE DESIGNER: Morris Fuller Benton (Franklin Gothic)

CONCEPT: "The electronic device and the vacuum tubes are to represent the experimentation of the musicians performing at the festival," says Thomas Scott of the central image of this poster.

INSPIRATION: "An attempt to find an interesting way to present a lot of information and still allow the poster to have a single, primary element."

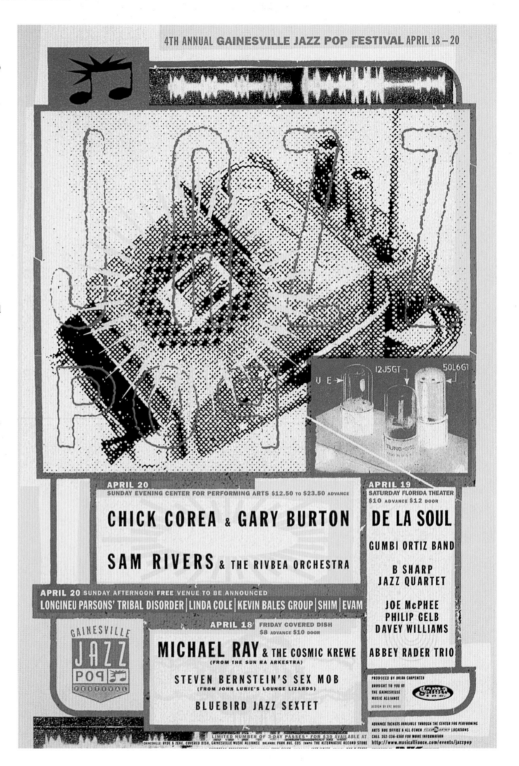

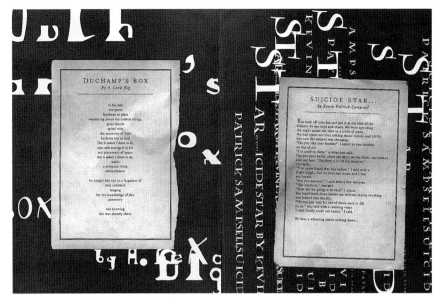

"PLAZM #6" POETRY SECTION

STUDIO: Plazm Media, Inc., Portland, OR

ART DIRECTORS: Joshua Berger, Niko Courtelis

DESIGNER: Niko Courtelis

CLIENT/PRODUCT: Plazm Media, Inc./magazine, digital type foundry, design firm

SOFTWARE: QuarkXPress, Adobe Photoshop

COLORS: One, match

PRINT RUN: 10,000

TYPEFACES: Caslon, Colony, Stele Bevel, Anvil, Able, Stele Regular, Mabbit

TYPEFACE DESIGNERS: Marcus Burlile (Colony, Stele Bevel, Anvil, Able, Stele Regular)

CONCEPT: For this poetry section for *Plazm* magazine, "I wanted to contrast experimental type with traditional typography, but still have a reverence for the poetry," says Niko Courtelis of Plazm. "The idea that these new poems could look like they were torn from an old chapbook and reproduced, with the bylines and titles treated more as texture, gave each poem its own distinct voice, while still looking like a cohesive section of the magazine."

INSPIRATION: "Classic" book typography.

SPECIAL COST-CUTTING TECHNIQUES: "Printing the entire poetry section on low-grade newsprint in one color gave this the vintage look we wanted and a more tactile form," says Niko Courtelis.

"MY YEAR OF MEATS" COVER

STUDIO: Paul Buckley Design, New York, NY

ART DIRECTOR/DESIGNER: Paul Buckley

ILLUSTRATORS: Ross MacDonald (spine line art), Tosa Mitsuoki (portrait of Sei Shōnagon, Edo Period, c. seventeenth century, Tokyo National Museum)

PHOTOGRAPHERS: Tom Baril (front cover), Paul Buckley (back cover)

CLIENT/SERVICE: Penguin Putnam Inc./publishing

SOFTWARE: QuarkXPress, Adobe Photoshop, Adobe Illustrator

COLORS: Four, process, plus two, match

PRINT RUN: 25,000

TYPEFACES: Opti Sport Script (title type), Champion HTF feather-weight (author type), Trade Gothic (text)

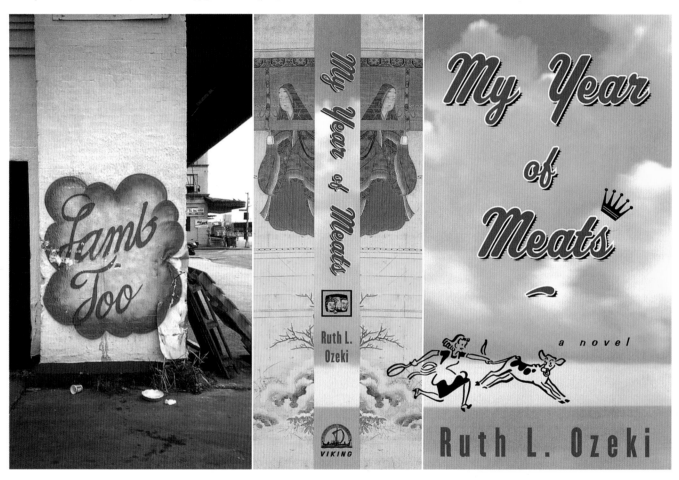

CONCEPT: "A very watered down Sue Coe for the masses," is the way Paul Buckley describes his book cover design for *My Year of Meats*. His objective was "to convey a fun, literary, yet commercial read with a message but without seeming preachy. Another challenge was to convey the stark contrast between Japanese and American sensibilities, which is a continuous current throughout this novel."

INSPIRATION: "In publishing like most other design gigs, you take the bad with the good—so when a hip, fun novel with a quirky title and a very cool author and editor comes along, that should be inspiration enough. And besides who wouldn't feel blessed to have the opportunity to design 'meat type' complete with a grand royalesque crown?"

SPECIAL TYPE TECHNIQUES: "A lot of meat signage has a great whole-some American values quality to it, very similiar to old fashioned base-ball type—the very values that this book exposes as being the last thing that the meat industry really cares about, but the first thing they would like to portray to the consumer public. This contrived graphic front cover, combined with the hyperrealistic and littered back cover photo containing real urban meat signage that looks like Looney Tunes gone wrong, is the true (uncomfortable)/false (comfortable) message I was trying to portray here.

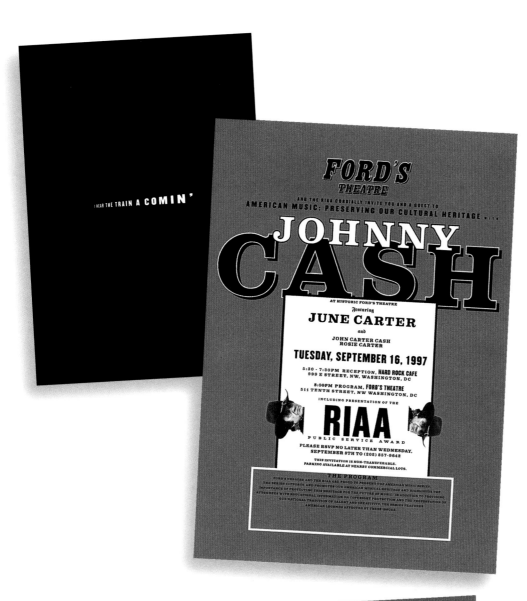

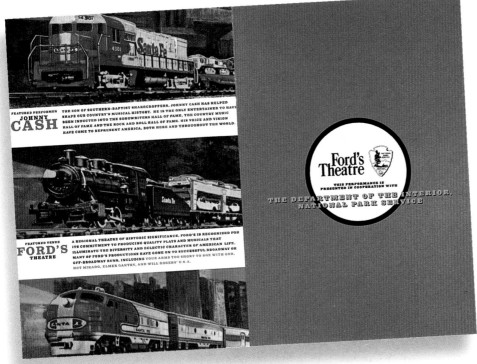

JOHNNY CASH INVITATION

STUDIO: Recording Industry Association of America, Washington, DC

ART DIRECTOR/DESIGNER: Neal Ashby

CLIENT/SERVICE: Recording Industry Association of America/trade group representing the major American record labels

SOFTWARE: QuarkXPress, Adobe Photoshop, Adobe Illustrator

COLORS: Four over four, process

PRINT RUN: 1,000

COST PER UNIT: $1.50 US

TYPEFACES: Champion (front cover, inside spread); Belizio ("Johnny Cash"); Headliner ("Ford's Theatre")

CONCEPT: "Since a lot of Johnny Cash's best songs are about trains," says designer Neal Ashby, "we decided to go with a train/Wild West theme for the invitation. The inside spread is a take on a Wild West poster with a modern twist. There is a little bit of layering that wouldn't have been done in that era, and I tilted the pictures of Johnny's head to make it a bit odd. But the typefaces seem to give it a western American feel."

SPECIAL TYPE TECHNIQUES: "Outlines and drop shadows for the words 'Johnny Cash' and 'Ford's Theatre' were done in Illustrator. For the cover, the words 'I hear the train a comin' were treated in Photoshop to give the perspective slant."

SPECIAL COST-CUTTING TECHNIQUES: "Illustrations of trains taken from a children's train catalog from the 1950s."

distortion and reconstitution

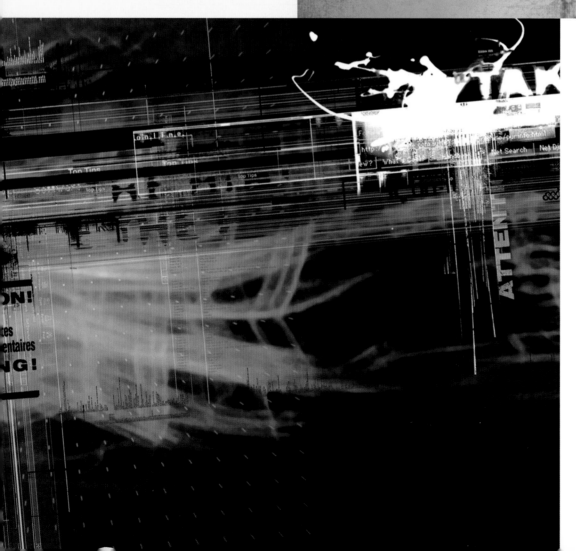

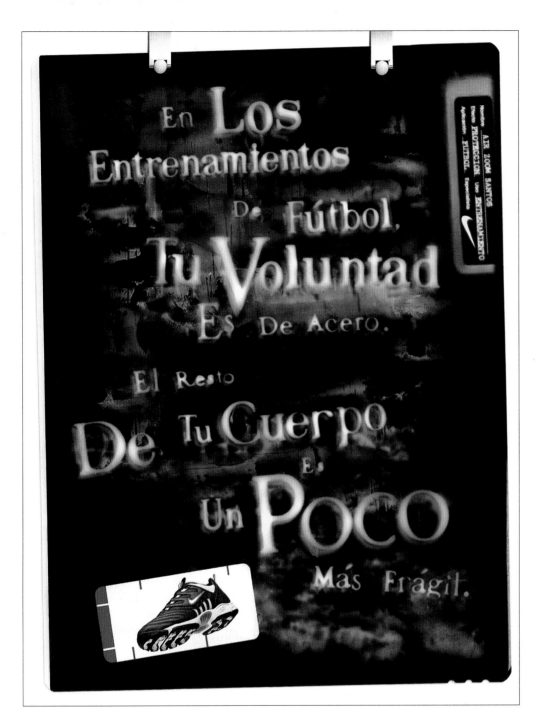

ART DIRECTOR/STUDIO: Niko Courtelis/Wieden & Kennedy, Portland, OR

DESIGNERS/STUDIO: Joshua Berger, Pete McCracken, John Kieselhorst/Plazm Media, Inc., Portland, OR

PHOTOGRAPHER: Mark Ebsen, Longview X-ray technology

CLIENT/PRODUCT: Nike/Air Zoom Santos soccer training shoes

SOFTWARE: QuarkXPress, Adobe Photoshop

COLORS: Four, process

TYPEFACES: Times Roman, Caslon

CONCEPT: The concept behind this athletic shoe ad was "to communicate the idea of the Air Zoom Santos's benefits through the treatment of the entire ad as an X-ray," says art director Niko Courtelis. "The headline, which was translated into several languages, says, 'During soccer training, you have an iron will. The rest of your body is a little more fragile.'"

SPECIAL TYPE TECHNIQUES: "Actually creating flat pieces of 'art' using large, laser-cut, metal type, wire, window screens, lead paint, pencil shaving, etc. and having them X-rayed at an industrial X-ray facility, then photographing all the elements (the shoe, clips, X-rays) and compositing them at the color house."

CENTER FOR PUPPETRY ARTS TICKET BROCHURE

STUDIO: EAI, Atlanta, GA

ART DIRECTOR: Matt Rollins

DESIGNER: Todd Simmons

ILLUSTRATOR: Todd Simmons

PHOTOGRAPHER: Center for Puppetry Arts

CLIENT/SERVICE: Center for Puppetry Arts/performance arts

SOFTWARE: Adobe Photoshop, QuarkXPress

COLORS: Two, match

PRINT RUN: 20,000

COST PER UNIT: $2.29 (with price breaks from printer and paper company)

TYPEFACES: Berthold Akzidenz Grotesk (manipulated)

CONCEPT: "While once its productions had been targeted exclusively to children, the CFPA introduced adult productions in the 1997–1998 season dealing with serious issues in a sophisticated, contemporary way," says designer Todd Simmons. "A strong promotional piece was needed to announce the change. The series was called 'New Directions' and the idea of this piece was to create an alternative image for the productions."

INSPIRATION: "The physical process of creating a puppet was kept very close in mind in the creation of this piece. Many puppets through the years have been created by exploring a gamut of mixed media, making for characters that are textural, dimensional and interactive. The definition of a puppet is any object given a personality and character."

SPECIAL TYPE TECHNIQUES:

"Although Akzidenz Grotesk was chosen throughout, in most cases it was radically altered. Typography was created through processes of hand-manipulating, etching, rubdowns and collage. Art was then transferred to digital and manipulated even further before final application, creating a desired effect that is unique for the CFPA."

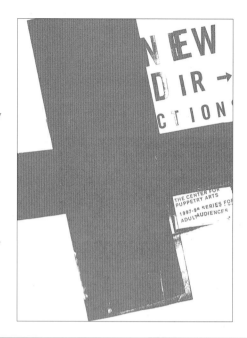

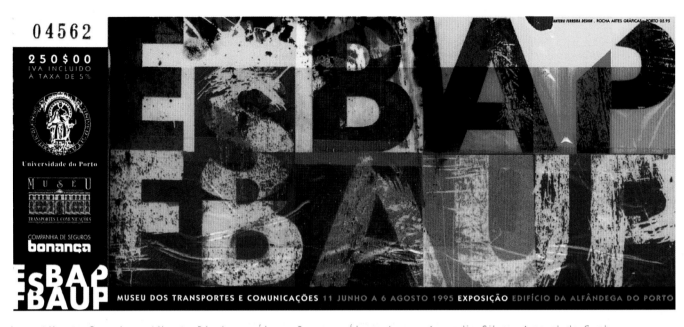

STUDIO: Antero Ferreira Design, Porto, Portugal

ART DIRECTOR: Antero Ferreira

DESIGNERS: Antero Ferreira, Celestino Fonseca

ILLUSTRATOR: Celestino Fonseca

CLIENT/PRODUCT: Oporto University/education

SOFTWARE: Macromedia FreeHand, Adobe Photoshop

COLORS: Four, process, over one, match

PRINT RUN: 10,000

TYPEFACE: Futura, Kabel

TYPEFACE DESIGNERS: Paul Renner (Futura), Rudolf Koch (Kabel)

CONCEPT: Antero Ferreira chose an all-type design for this exhibition ticket. The title of the exhibition (ESBAP-FBAUP) merges the initials of the old and the new Oporto Fine Arts schools, and Ferreira made this title the primary image; the back of the ticket lists all the exhibiting artists.

SPECIAL TYPE TECHNIQUES: The lettering began with the manipulation of Futura in FreeHand, which was then brought into Photoshop and further manipulated.

INDEX A

STUDIO: Automatic Art and Design, Columbus, OH

ART DIRECTOR/DESIGNER: Charles Wilkin

ILLUSTRATOR: Charles Wilkin

CLIENT/SERVICE: Automatic Art and Design/design

SOFTWARE: QuarkXPress, Adobe Photoshop

COLORS: Four, process

PRINT RUN: 2,500

TYPEFACES: Folio, Frankie, Trixie

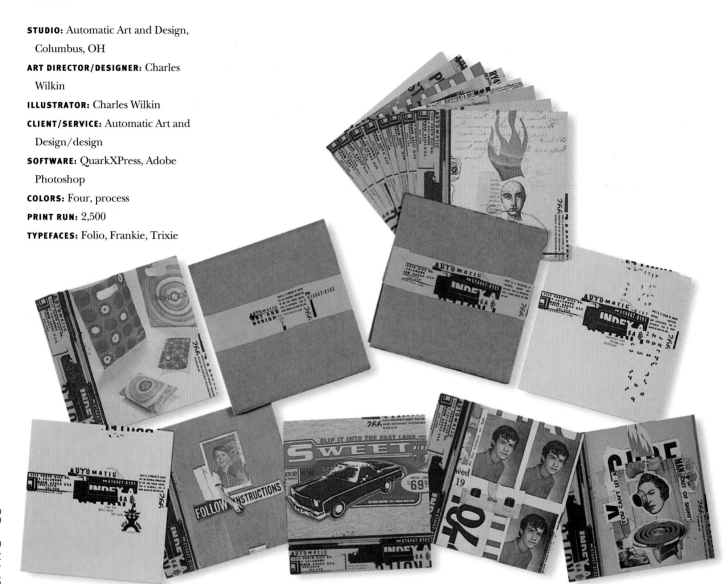

CONCEPT: "Index A is a collection of thoughts, images and instinct which documents the design and illustration work of Automatic Art and Design," says Charles Wilkin of this self-promotion piece for his studio. "It consists of a series of fifteen postcards which were inspired by old index cards found at flea markets. Illustration and print work are featured on the front, while typeface and logo design are on the back. The cards can be placed in between two pieces of cardboard and sealed with a wrap, creating a packet of work, or mailed individually."

INSPIRATION: "Index and flash cards."

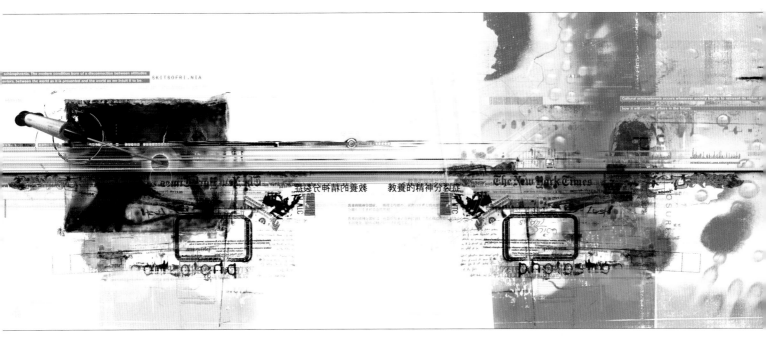

STUDIO: The Attik, Huddersfield and London, England, and New York, NY

PRESIDENT/EXECUTIVE PRODUCER: William Travis

GROUP CREATIVE DIRECTOR/ MANAGING DIRECTOR: James Sommerville

GROUP CREATIVE DIRECTOR/SALES DIRECTOR: Simon Needham

CREATIVE DIRECTOR, NEW YORK: Simon Dixon

DESIGNER: Simon Dixon

PHOTOGRAPHER: Peter Heaton

CLIENT/PRODUCT: *Wired* magazine/ new media magazine

SOFTWARE: Adobe Photoshop, Macromedia FreeHand, Adobe Illustrator

COLORS: Four, process, plus two, spot

CONCEPT: Simon Dixon says that this layout for *Wired* magazine "was based on cultural schizophrenia— the design an extension of this. Conflicts and aggravated interactions created a tension to the layout, which was balanced with more delicate calmer elements. Overall the intention was to create an environment that was controlled chaos.

"The piece was an experiment in information communication," says Dixon. "It was developed using a wide range of techniques: photo-illustration, collage, typography, 3-D rendering and graphics. These elements were combined to create one hybrid visual, blending the boundaries between the traditional divisions of these media to create a cohesive unit."

SPECIAL PRODUCTION TECHNIQUES: "The basis of the layout was a collage of found materials, including a dollar bill, receipts, paper scraps and handwriting. These were scanned after first being burnt and degraded. The computer-generated elements were then layered with the scans and abstract photography producing a four-color process layout. Extra detail and typography were added as special colors—silver and lime green.

"The design uses Photoshop in a very intensive and bastardized way. Having the ability to layer hundreds of individual elements into one file, then having finite control over each one, has definite advantages. Once the elements are combined, the design can be spontaneous and intuitive as the various elements are effected and manipulated in relation to each other. This gives a high degree of fine control, while allowing a flexibility to react and change to the combination of elements."

MASSART CATALOG 1997-1999

STUDIO: Stoltze Design, Boston, MA

ART DIRECTOR: Clifford Stoltze

DESIGNERS: Tammy Dotson, Wing Ngan, Angelia Geyer, Clifford Stoltze

PHOTOGRAPHERS: Guy Michel Telemaque, Michael Cogliantry, Oscar Palacio, Daniel Szabo

CLIENT/SERVICE: Massachusetts College of Art/state-funded arts education

SOFTWARE: Adobe Photoshop, QuarkXPress, Adobe Illustrator

COLORS: Four, process, and two, match

PRINT RUN: 25,000

COST PER UNIT: $4.15 US

TYPEFACES: Futanaltal, Tasse, Cornwall, Mrs. Eaves

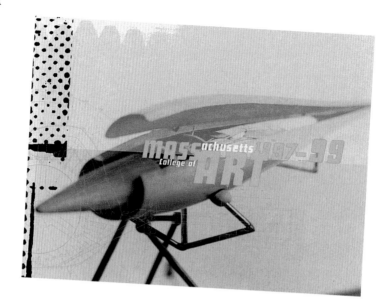

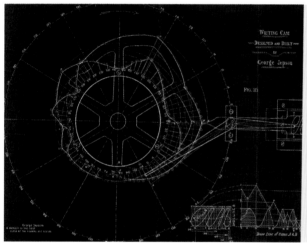

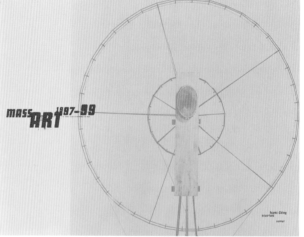

CONCEPT: "We wanted a look that was both high-tech and organic," says Clifford Stoltze of this catalog for an art college. "We tried to achieve this by using computer technology and handmade artwork to create a collaged and highly customized design."

SPECIAL TYPE TECHNIQUES: "Typography was highly customized in terms of layout and manipulation (noise was added to the headlines)."

SPECIAL PRODUCTION TECHNIQUES: The use of colored Quark duotones.

SPECIAL COST-CUTTING TECHNIQUES: The piece was web-printed in a combination of four-color process and two Pantone colors; the designers also managed to reduce the number of pages overall by fitting a lot of information on each page.

"BEDSIDE TOXICOLOGY" POSTER

STUDIO: SRG Design, Los Angeles, CA

ART DIRECTOR/DESIGNER: Steven R. Gilmore

ILLUSTRATOR: Steven R. Gilmore

PHOTOGRAPHER: Jessika White

CLIENT/SERVICE: Invisible Records/record company

SOFTWARE: Macromedia FreeHand, Adobe Photoshop

COLORS: Four, process

TYPEFACES: Bell Gothic, Kunstler Script

CONCEPT: "In keeping with the supplied self-portraits by Jessika White, I wanted the poster and compact disc sleeve to maintain a dark medical overtone and the sense of being locked away in an insane asylum," says Steven Gilmore.

INSPIRATION: "The effects of the drug Ritalin on children."

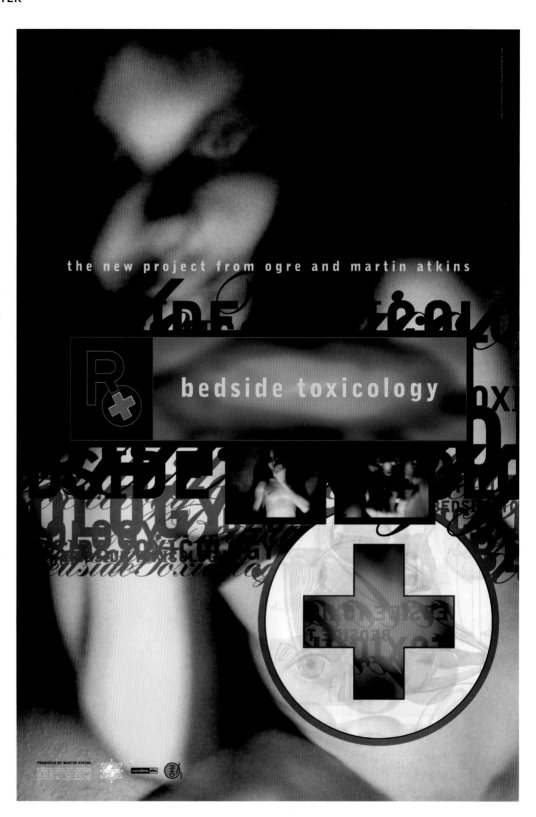

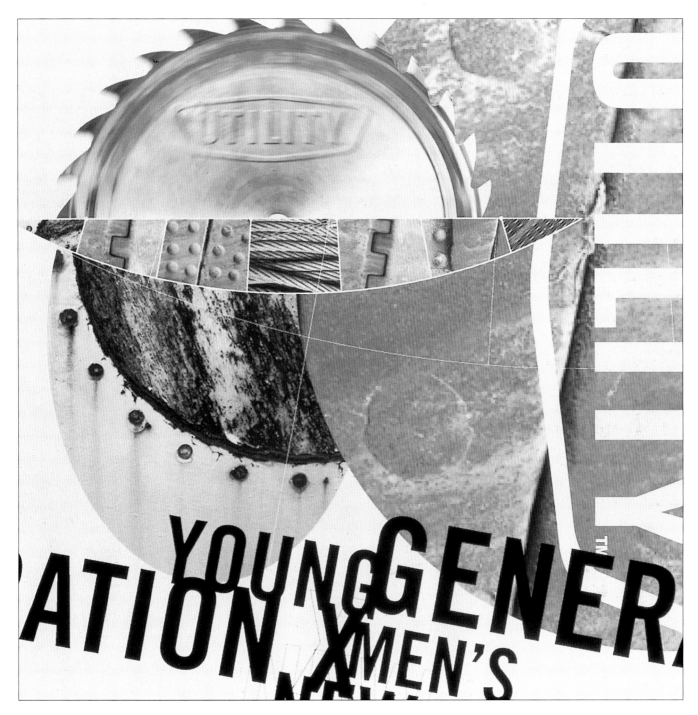

UTILITY POSTER

STUDIO: Design Guys, Minneapolis, MN

ART DIRECTOR: Steven Sikora

DESIGNER: Jay Theige

PHOTOGRAPHER: stock photography

CLIENT/PRODUCT: Target/line of young men's clothing for discount retail store

SOFTWARE: Adobe Photoshop, Adobe Illustrator

COLORS: Four, process

TYPEFACE: Trade Gothic Condensed Bold

CONCEPT: "The fragmented imagery of an ever more complex and multilayered world" is how Steven Sikora of Design Guys describes the look of this piece. "The copy was reinterpreted by cutting, disjoining and colliding words, reinforcing their meaning."

INSPIRATION: "Scenes of industrial/urban decay, street life, aggressive sports such as skateboarding or in-line skating, rave events, disposable fashion, Generation X," says Sikora.

SPECIAL PRODUCTION TECHNIQUES: "Lots and lots of images combined with fragmented word forms."

SPECIAL COST-CUTTING TECHNIQUES: Photography was sourced from a copyright-free stock photo CD and the finals were printed as large-format color outputs.

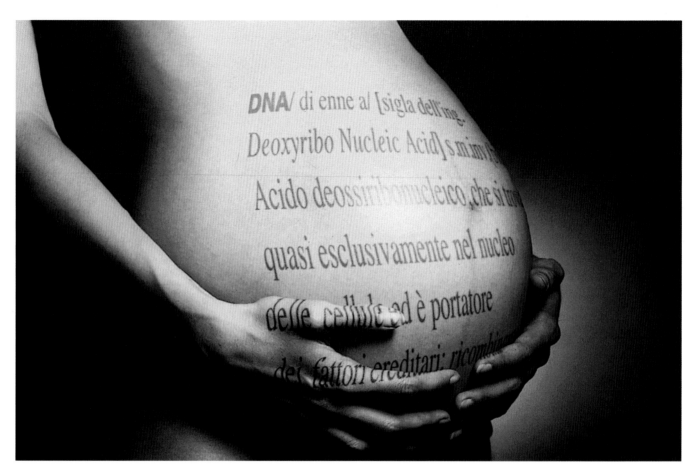

ART DIRECTOR/AGENCY: Patrizio Marini/J. W. Thompson, Rome, Italy

DESIGNER/STUDIO: Fabrizio Gennenzi, The Looking Glass Factory, Rome, Italy

PHOTO MANIPULATION: Fabrizio Gennenzi

PHOTOGRAPHER: Alessandro Valeri

CLIENT/SERVICE: BNL/telethon

SOFTWARE: Adobe Photoshop

COLORS: Four, process

PRINT RUN: 150,000 in different media (posters, billboards, folders, press kits)

TYPEFACE: Times

CONCEPT: The Looking Glass Factory created this striking merger of type and image as the central image for a telethon to fight genetic disease.

STUDIO: Allen Craig Communication Design, San Francisco, CA

ART DIRECTOR: Allen Schlossman

DESIGNER: Bonnie Ralston

CLIENT/PRODUCT: IA Corporation/bank processing software

SOFTWARE: QuarkXPress, Adobe Photoshop

COLORS: Two, match

PRINT RUN: 1,000

COST PER UNIT: $2 US

TYPEFACES: Univers Condensed, Adobe Caslon

CONCEPT: "The invitation was for a company gathering at a downtown fine art gallery," says art director Allen Schlossman. "We decided to make the piece intriguing by drawing the viewer into its space through its multi-dimensionality. We wanted the design to extend beyond the two-dimensional plane of the paper, and achieved this through layering on multiple levels. Using translucent stock, printing on both sides (sometimes mirroring what is printed on front by printing backwards on the back), overprinting and having the piece fold over itself all contributed to this feeling of dimensionality."

SPECIAL TYPE TECHNIQUES: Allen Schlossman says that, though his studio was restricted to the use of the client's corporate type families, "we also knew we wanted our type choices to appear unique. To achieve natural movement, we took selected groups of copy from our layout, output them on our laser writer and spent half a day experimenting with the Xerox machine. We reduced, enlarged and re-reduced, we pulled our copy across the scanning bed as it was being copied, and we held the copy off the scanning bed and copied. After choosing from the results, we scanned in the individual scraps as live art and composed it in the page layout program."

SPECIAL COST-SAVING TECHNIQUES: "The invitation was designed to fit into pre-made translucent envelopes, saving on custom envelope conversion. They were printed as a work-and-turn on parent-sized sheets so a minimum amount of paper was used. We mixed varnishes in with our inks, allowing us to avoid needing a second pass or having to go to a larger press. The slightly reduced opacity played right into our design."

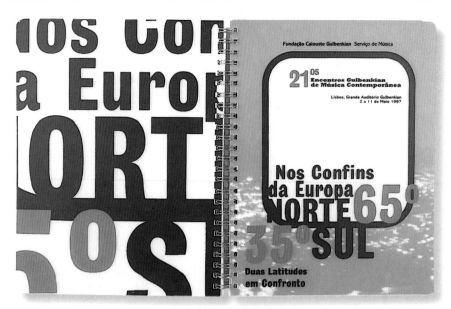

STUDIO: Centradesign, Lisbon, Portugal

ART DIRECTOR/DESIGNER: Ricardo Mealha

ILLUSTRATOR: Ricardo Mealha

PHOTOGRAPHER: Photodisc/Adriana Freire

CLIENT/SERVICE: Calouste Gulbenkian Foundation/yearly contemporary music festival organized by the Calouste Gulbenkian Foundation Music Department

SOFTWARE: QuarkXPress, Adobe Photoshop, Macromedia FreeHand

COLORS: Four, process

PRINT RUN: 2,000

COST PER UNIT: $5 US

TYPEFACES: Monotype Headline, Abadi

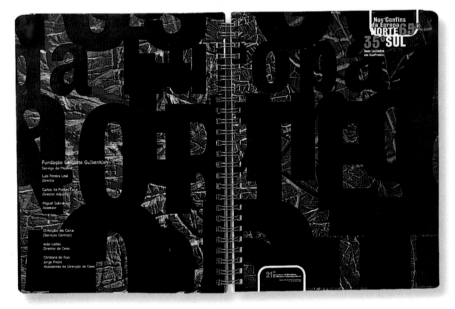

CONCEPT: "The main theme of this festival was the confrontation of northern and southern contemporary music composers, so I created an image for the cover of the catalog that has a certain spirit of tension," says Ricardo Mealha of his music festival catalog design. "The picture could be of a city at night anywhere in Europe and the colors are dark."

SPECIAL TYPE TECHNIQUES: "Just some type juxtaposition to illustrate the pages of the days of the festival."

SPECIAL PRODUCTION TECHNIQUES: The piece was printed on a Xeikon digital offset printer, to cut costs.

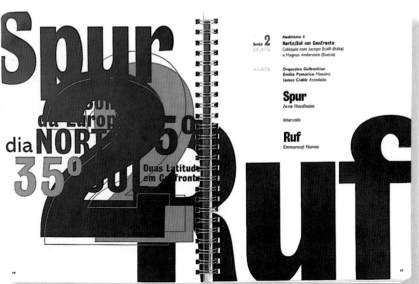

Orquestra Gulbenkian

Fundada em 1962 pela Fundação Calouste Gulbenkian, a Orquestra Gulbenkian é reconhecida, nacional e internacionalmente, como a mais importante formação orquestral portuguesa. Com um efectivo permanente de 60 músicos, que pode ser pontualmente expandido de acordo com as exigências dos programas executados, a Orquestra Gulbenkian adoptou uma constituição intermédia entre a formação de câmara e a sinfónica. Como tal, pode interpretar um vasto repertório que não só abrange toda a herança orquestral do período Clássico e do início do Romantismo, como também um número significativo de música dos séculos XIX e XX.

Os programas da Orquestra Gulbenkian incluem com frequência composições raramente ouvidas de diferentes autores e períodos históricos, juntamente com novas obras de música contemporânea, entre as quais se destacam estreias mundiais de várias peças encomendadas pela própria Fundação Calouste Gulbenkian a alguns dos mais representativos compositores do nosso tempo — Berio, Milhaud, Penderecki, Halffter, Xenakis, Krausze, Emmanuel Nunes e muitos outros — bem como a praticamente todos os principais compositores portugueses da segunda metade do século XX.

A Orquestra Gulbenkian tem realizado extensas digressões na Europa (Espanha, França, Inglaterra, Bélgica, Suíça, Itália e antiga União Soviética), Brasil, Ásia (República Popular da China, Hong Kong, Macau, Índia e Tailândia) e África. Em 1992, as digressões internacionais incluíram a participação no Festival Europália em Bruxelas, nas séries de concertos de Madrid' 92 – Capital Europeia da Cultura, na Expo' 92 em Sevilha, no Festival de Outono de Paris e no Festival de Compiègne (estreia de Christophe Colombe de Darius Milhaud). Em 1993 a Orquestra actuou na Tailândia e foi convidada para realizar uma extensa digressão de oito concertos nas principais cidades do Japão (incluindo o Auditório Santori em Tóquio). Em Novembro desse ano foi a única orquestra portuguesa a participar no Festival Europa Musicale (Munique), uma iniciativa lançada pelo então Presidente da Comissão Europeia, Jacques Delors, e que reuniu as mais importantes orquestras europeias. Em 1994, ano em que Lisboa funcionou como Capital Cultural Europeia, a Orquestra Gulbenkian esteve grandemente absorvida pelo seu papel de participante-chave nas programações artísticas deste evento, mas conseguiu ainda representar Portugal no Mês Cultural Europeu em Budapeste, juntamente com o Coro e o Ballet Gulbenkian. Em 1995 participou como orquestra convidada no Festival Internacional de Música de Santander (em colaboração com o Concurso Internacional de Piano Paloma O'Shea), e realizou uma extensa digressão à América do Sul, com actuações em várias cidades do Brasil, Uruguai e Argentina. Já no decurso da temporada de 1995-1996, a Orquestra Gulbenkian concluiu recentemente uma digressão coroada de êxito na Alemanha e Áustria.

A Orquestra Gulbenkian gravou um elevado número de discos na interpretação de um vasto repertório para as companhias discográficas Philips, Archiv-Deutsche Grammophon, Erato, Adès, Lyrinx, Cascavelle, Musifrance, Marco Polo e FNAC-Musique, os quais foram consecutivamente galardoados com alguns dos mais importantes prémios internacionais e recebidos com excelentes críticas. Edições recentes incluem gravações para a Nimbus com obras de Méhul, Offenbach, Waldteufel, Weill e Ives, sob a direcção de Michel Swierczewski, três CD's com obras de Honneger para a Cascavelle, sob a direcção de Michel Corboz, assim como da Missa de Santa Cecila de Haydn, dos Requiems de Verdi e de João Domingos Bomtempo, da Messa di Gloria de Puccini e do Gloria de Poulenc, para a FNAC-Musique, igualmente sob a direcção de Michel Corboz. Vários outros projectos estão já calendarizados ou em preparação para os próximos anos.

Muhai Tang é o actual Maestro Titular da Orquestra Gulbenkian. A partir da temporada de 1995-1996, Claudio Scimone, que exerceu as funções de Maestro Titular (1981-1988) e Maestro Convidado Principal (1988-1995), passou a desempenhar as de Maestro Convidado Honorário desta formação, e Michael Zilm substituiu-o nas de Maestro Convidado Principal. Desde 1984, Max Rabinovitsj é o Concertino Principal e Maestro Adjunto da Orquestra Gulbenkian.

24

BIO-BOX CASSETTE PACKAGING

STUDIO: Automatic Art and Design, Columbus, OH

ART DIRECTOR/DESIGNER: Charles Wilkin

ILLUSTRATOR: Charles Wilkin

CLIENT/PRODUCT: Bio-Box/audio and video cassette packaging development and manufacturing

SOFTWARE: QuarkXPress, Adobe Illustrator

COLORS: Four, process

TYPEFACE: Folio

CONCEPT: "I was given total creative freedom with this project," says Charles Wilkin of this packaging design. "My only requirement was that the boxes feel like a series. While I was working on the illustrations, I found an old journal with inspirational quotes for each day. I edited the quotes into obscure sentences, like 'Wednesday 5, you can't live on amusement' or 'Thursday 20, coil spring smoothness.' I then incorporated these new phrases into the illustrations. The result was a juxtaposition of words and images which reinterpreted the original journal, while the chronological order of the dates held the boxes together as a series."

SPECIAL TYPE TECHNIQUES: "I collaged type I found in old magazines."

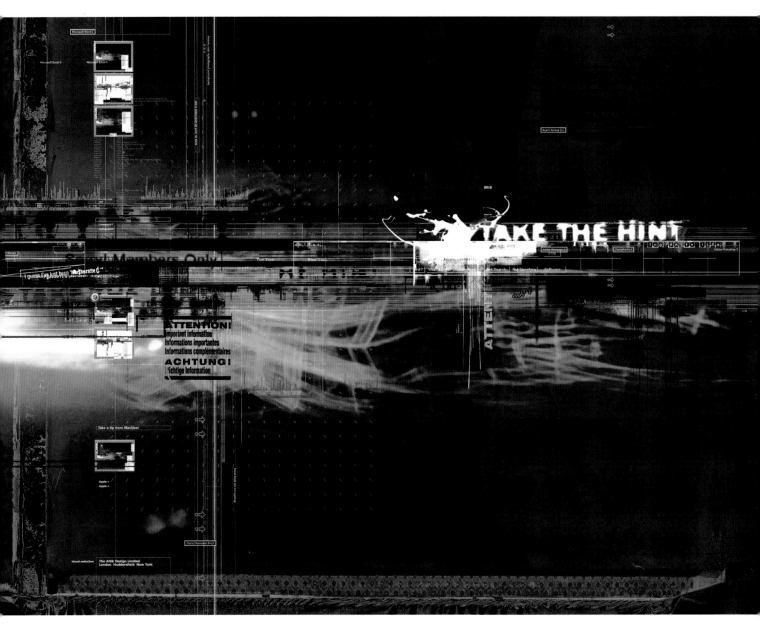

STUDIO: The Attik, Huddersfield and London, England, and New York, NY

PRESIDENT/EXECUTIVE PRODUCER: William Travis

GROUP CREATIVE DIRECTOR/ MANAGING DIRECTOR: James Sommerville

GROUP CREATIVE DIRECTOR/SALES DIRECTOR: Simon Needham

CREATIVE DIRECTOR, NEW YORK: Simon Dixon

DESIGNER: Simon Dixon

PHOTOGRAPHER: John Horsely

CLIENT/PRODUCT: *MacUser* magazine/magazine

SOFTWARE: Adobe Photoshop, Adobe Illustrator, Macromedia FreeHand

COLORS: Four, process

TYPEFACE: Akzidenz Grotesk, found text

CONCEPT: According to Simon Dixon, "This image was created to illustrate an article on Macintosh computer tips and hints. The image was a digital information mass, linking visually to the technical information within the text. The vernacular of technology magazines was degraded and bastardized, then reconstituted into digital communication that was expressive and illustrative in its final version. There were also several detailed references to the bulk of the text."

AMAMXX

0 84418 22602 3

(01) FLESH:WOUND
(02) COBALT
(03) UNMADE
(04) GRIPPED
(05) EPITOME
(06) THE GLIMPSE

...& HAND BRUSHED (07)
BY TIRED EYES
DROP CIRCLES (08)
DEEP HEAVEN (09)
DROP (10)
FORGIVEN (11)
BRIGHTBLUR (12)

℗ MCMXCVII Tattoo Records, a division of Benson
Records, Inc. Distributed in the United States by
Provident Music Distribution, Inc., One Maryland
Farms, Brentwood, TN 37027. All rights reserved.
Unauthorized duplication prohibited.

TATTOO records

MASSIVIVID "BRIGHTBLUR" MUSIC PACKAGING

STUDIO: Kerosene Halo, Chicago, IL

ART DIRECTORS: Gregory Sylvester, Thomas Wolfe

DESIGNER: Thomas Wolfe

PHOTOGRAPHERS: Jeff Sciortino (band photography), Gregory Sylvester (tabletop stills)

CLIENT/SERVICE: Tattoo Records/ record label

SOFTWARE: Adobe Illustrator, Adobe Photoshop, QuarkXPress

COLORS: Four, process

PRINT RUN: 10,000-20,000

TYPEFACES: Orav (album title and text), Metro (artist name), Avenir (artist name)

TYPEFACE DESIGNER: Eyesaw (Orav)

CONCEPT: Says Gregory Sylvester of Kerosene Halo, "In a novel by author C.S. Lewis, two men were discussing how each other imagined God. One man's response was, 'God is a bright blur, and the more I come to understand Him the brighter and more blurry He becomes.' This was the inspiration for the title of Massivivid's debut album *BrightBlur*. We decided to visually illustrate this by presenting the band as if they were standing before God. We asked ourselves how one would prepare to go before the BrightBlur. The imagery of welding goggles and fire-retardant clothing illustrates the impossible task of man making an actual attempt to meet God on earth."

SPECIAL TYPE TECHNIQUES: "Typographically, our intention was to convey the mechanical nature of the music," says Sylvester. "This was accomplished through the typeface Orav, which is a standard OCRB font with several of its characters transposed, flipped and reflected."

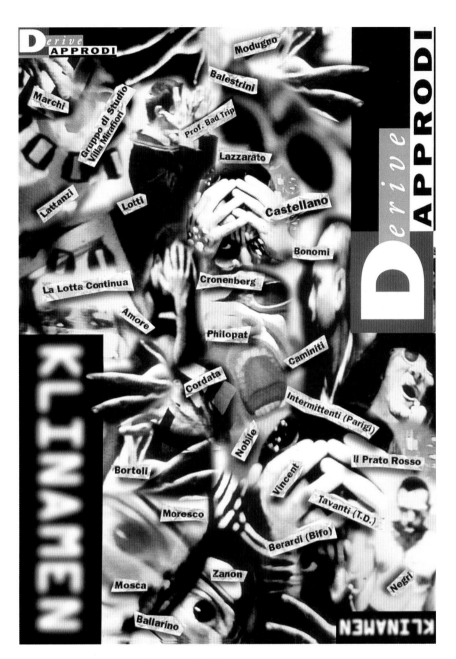

"DERIVE APPRODI" ISSUE #3 COVER

STUDIO: The Looking Glass Factory, Rome, Italy

ART DIRECTOR/DESIGNER: Massimo Kunstler

PHOTOGRAPHERS: Manolo Luppichini, Massimo Di Felice

CLIENT/PRODUCT: *Derive Approdi*/magazine

SOFTWARE: Adobe Photoshop, Adobe Illustrator, QuarkXPress

NUMBER OF COLORS: Two, match

PRINT RUN: 3,000

COST PER UNIT: L. 10.000 (approximately $6 US)

TYPEFACES: Franklin Gothic Heavy, OCRA, Garamond

CONCEPT: Massimo Kunstler describes this magazine cover as "a collection of about fifteen different pictures that I merged together to create a strong new single image to give a smashing visual impact."

WE HAVE MOVED

STUDIO: The Attik, Huddersfield and London, England, and New York, NY

PRESIDENT/EXECUTIVE PRODUCER: William Travis

GROUP CREATIVE DIRECTOR/ MANAGING DIRECTOR: James Sommerville

GROUP CREATIVE DIRECTOR/SALES DIRECTOR: Simon Needham

CREATIVE DIRECTOR, NEW YORK: Simon Dixon

DESIGNER: Steven Wills

PHOTOGRAPHER: Steven Wills

CLIENT: The Attik/design

SOFTWARE: Macromedia FreeHand, Adobe Photoshop

COLORS: Four, process

PRINT RUN: 2,000

COST PER UNIT: 70p UK

TYPEFACE: Swiss 721, found fonts from plane and rail tickets

CONCEPT: According to Steven Wills, the idea behind this moving notice for The Attik was "to produce a very 'gritty' piece of design that would stand out from the crowd while getting the concept of 'moving' across. I used my own photography and collections from various forms of transports."

INSPIRATION: "Coming from the north of England, I wanted to get across the industrial feel of Huddersfield which is the Attik's roots."

SPECIAL PRODUCTION TECHNIQUES: "The individual cards were printed on the same card as beer mats, and the white hole indicated where a heavy-duty nut and bolt holds the card together."

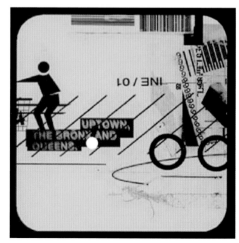

STUDIO: Paul Buckley Design, New York, NY

ART DIRECTOR/DESIGNER: Paul Buckley

JACKET ILLUSTRATION: H. Steinegger, *General Custer's Death Struggle*, ca. 1876, Library of Congress

BACK COVER PHOTOGRAPHY: courtesy of the author

CLIENT/SERVICE: Penguin Putnam Inc./publishing

SOFTWARE PROGRAMS USED: QuarkXPress, Adobe Photoshop

MATCH OR PROCESS: Four, process, plus one, metallic match

PRINT RUN: 20,000

TYPEFACE: Clarendon, Egiziano, various others photocopied out of old alphabet collections

CONCEPT: "This book contains a never-before-published, first-person account of Custer's last battle that was stored away in someone's attic and then bought by Greg Martin at auction. Therefore, I wanted the cover to look as authentic as possible," says Paul Buckley of this book cover design.

INSPIRATION: "While I am not a Civil War buff, I do enjoy the challenge of mimicking a design aesthetic from the past," says Buckley. "It can be a nice respite from the constant pressures and challenges of coming up with something fresh that so many other book topics require. In this particular instance, though, I do feel that I had solutions that were much more successful than this final jacket but the materials, fonts and overall look were eventually compromised by overthinking marketing concerns."

SPECIAL TYPE TECHNIQUES: "The obvious solution here was to make this look like an authentic document of its era; therefore, the printing grit and inconsistencies. This meant reliving lots of hours of good old-fashioned cut-and-paste exercises, as well as paging through old type books instead of scrolling. The entire job was done as a board mechanical."

conceptually driven

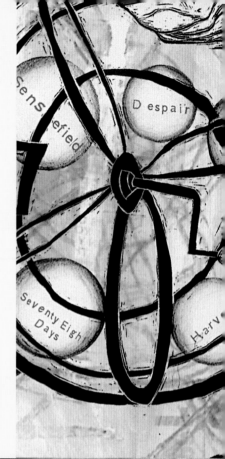

SenSefield Despair

Seventy Eight Days Harve

mmpplle

olbtlie

u

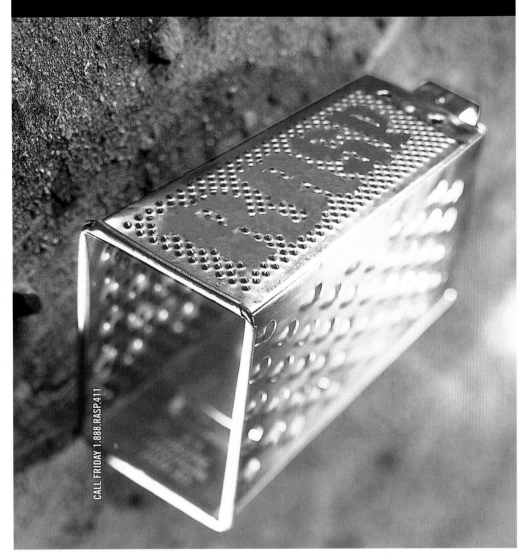

THE FAT CUTTING EDGE

INNOVATIVE NEW WHEELS, GRIND PLATES, RAILS, PROTECTIVE GEAR AND APPAREL THAT YOU CAN TAKE A HAMMER TO. MADE ENTIRELY OF RAW MATERIALS. FOUND TO BE COMPLETELY INSENSITIVE TO ABUSE.

CALL FRIDAY 1.888.RASP-411

RASP GRATER AD

STUDIO: Design Guys, Minneapolis, MN

ART DIRECTOR: Steven Sikora

DESIGNER: Mitch Morse

CLIENT/PRODUCT: Mid Coast/aggressive in-line skate products

SOFTWARE: Adobe Photoshop, Adobe Illustrator, QuarkXPress

COLORS: Four, process

PRINT RUN: distribution of *Box* magazine and *In-line* magazine

TYPEFACE: Trade Gothic Condensed, Trade Gothic Bold Condensed

LOGOTYPE DESIGNER: Jay Theige

CONCEPT: This ad for in-line skating products uses a cheese grater for its central image as a reference to "grinding," a practice in in-line skating where the participant gains speed and leaps up onto a handrail, edge of a bench or planter and "grinds" along on a place between his wheels until losing momentum and returning to the ground. Says art director Steven Sikora, "Grinds are not always successful, pavement is inevitably hard and often textured—the cheese grater serves as metaphor. Think of a grater scrapping against a slab of aged Romano."

SPECIAL TYPE TECHNIQUES: RASP Logotype is hand-drawn in solid and outline versions in Adobe Illustrator by Jay Theige.

SPECIAL PRODUCTION TECHNIQUES: Photoshop manipulation of the image enabled the inclusion of the RASP logotype on the grater body.

SPECIAL COST-CUTTING TECHNIQUES: "Use of my own cheese grater," says Sikora.

XILINX ANNUAL REPORT

STUDIO: Cahan and Associates, San
Francisco, CA

ART DIRECTOR: Bill Cahan

DESIGNER: Kevin Roberson

PHOTOGRAPHER: William Mercer
McLeod

CLIENT/PRODUCT: Xilinx/program-
mable logic devices

SOFTWARE: QuarkXPress

COLORS: One, black (cover wrap);
four over four, process (text); one
over one, black (financials)

PRINT RUN: 40,000

TYPEFACES: Caslon, various found
letters

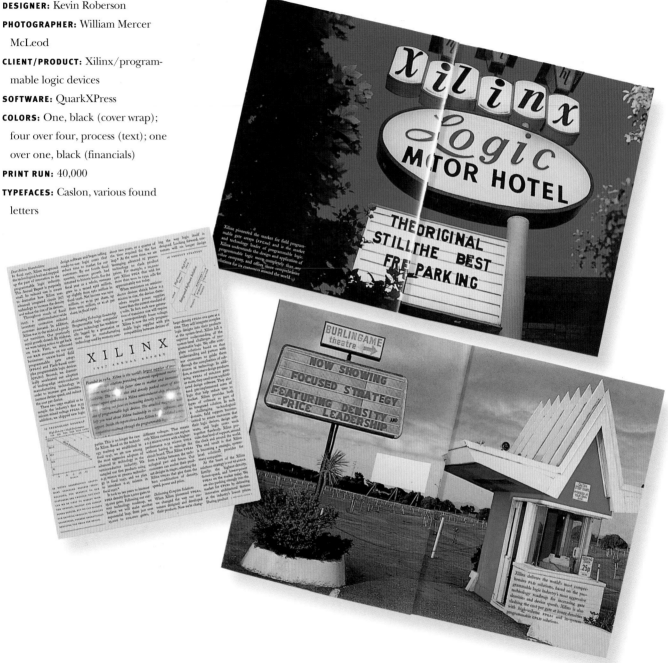

CONCEPT: The reduced size and densely packed cover of this Xilinx annual report symbolize a Xilinx semi-conductor chip, demonstrating a focus on increasing density while reducing size. The attached magnifying lens allows the reader to zoom in on the text and detailed charts. Inside, photos reveal a series of attractions along the "Technological Highway" with the signage changed to reveal Xilinx's key messages.

"OBLIVION" BOOK COVER

STUDIO: Penguin Putnam Inc., New York, NY

ART DIRECTOR: Paul Buckley

DESIGNER: Martin Ogolter

CLIENT/SERVICE: Penguin Putnam Inc./publishing

SOFTWARE: QuarkXPress, Adobe Photoshop

COLORS: Four, match

PRINT RUN: 9,000

TYPEFACE: Bulmer

CONCEPT: "The main character of this novel," says Martin Ogolter, "has to deal with the fact that after his wife's death, all aspects of life are in one way or the other connected with his dead spouse, and he constantly has to deal with facts of the past in the present. I wanted to show that back and forth just with type and let the other abstract shapes set the mood for the rest of the cover."

2001 LOGO

STUDIO: STUDIO INTERNATION-AL, Zagreb, Croatia

ART DIRECTOR/DESIGNER: Boris Ljubicic

ILLUSTRATOR: Boris Ljubicic

PHOTOGRAPHER: Boris Ljubicic

CLIENT/SERVICE: STUDIO INTER-NATIONAL/design

SOFTWARE: CorelDraw

COLORS: Various, depending on the application

TYPEFACES: Times New Roman (numerals 1 and 2); Futura Light (numeral 0)

CONCEPT: Observing that "there are a number of projects that need a mark for the new millennium because of their nature and purpose (books, publications, posters, TV and video, souvenirs)," Boris Ljubicic says that this logo "marks the transition from the rational language of typography into a language of the visual. The logo is made up of two typefaces, Times and Futura. Indirectly, one could say it is a compound of Time and Future."

SPECIAL COST-CUTTING TECHNIQUES: The possibility of reduction of colors (from four to one) without lessening the strength and the impact of the logo.

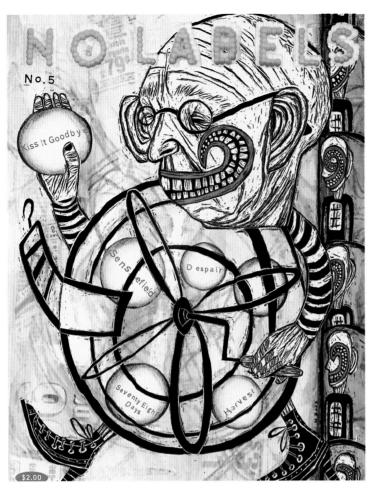

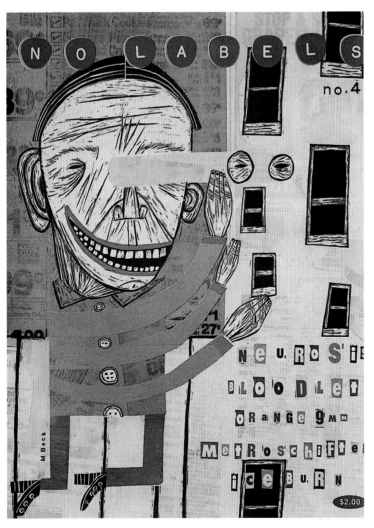

"NO LABELS" COVERS

STUDIO: Melinda Beck Studio, New York, NY

ART DIRECTOR/DESIGNER: Melinda Beck

ILLUSTRATOR: Melinda Beck

CLIENT/PRODUCT: *No Labels* magazine/music magazine

SOFTWARE: QuarkXPress, Adobe Photoshop

COLORS: Two, match

TYPEFACE DESIGNER: Melinda Beck

CONCEPT: "*No Labels* is a venue for independent music labels and bands," says Melinda Beck of the covers she has designed for this magazine. "The design's low-tech do-it-yourself look was created to complement the content of the magazine. The illustration and the typography were created to work as one integrated piece."

SPECIAL TYPE TECHNIQUES: "The typefaces were created by using old typewriter keys, cake letters, rubber stamp letters and letters cut from a supermarket circular."

SPECIAL PRODUCTION TECHNIQUES: The design was created by combining digital art and handwork.

SPECIAL COST-CUTTING TECHNIQUES: "There was no budget for illustration or photography, so I created the illustration myself and put objects directly onto my scanner rather than having them photographed."

DANA ARNETT/UNCOMPLICATED

STUDIO: Ashby Design, Washington,
DC

ART DIRECTOR/DESIGNER: Neal Ashby

CLIENT/SERVICE: AIGA Washington/
AIGA speaker series

SOFTWARE: QuarkXPress, Adobe
Photoshop

COLORS: Four, process, over one,
black

PRINT RUN: 5,000

COST PER UNIT: printing
done pro bono

TYPEFACE: Bureau
Grotesque

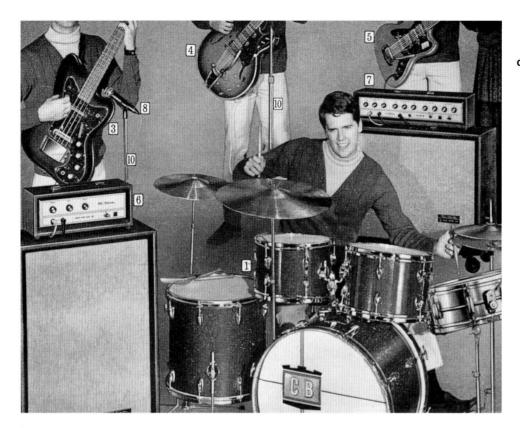

CONCEPT: "I called Dana the night before I designed the invitation to find out what he was going to be talking about," says Neal Ashby about this invitation for an AIGA lecture given by Chicago-area designer Dana Arnett. "He said the unofficial title of his speech was 'uncomplicated.' I decided to make that the title of the program. To follow through with that concept, I designed the cover and the inside covers to be completely white. Then I wanted to do the entire inside with no words at all, just scenes of uncomplicated life from found pictures in old Sears, J.C. Penney and Montgomery Ward catalogs. The cover, however, secretly opens to reveal the large message 'Dana Arnett/Uncomplicated.' Like Dana's deceptively simple design work, the cover has a deeper message hidden within."

SPECIAL PRODUCTION TECHNIQUES: "Using 'replace color' and 'selective color' modes in Photoshop," Ashby says, "we managed to bring new vibrant color to the aging catalog pictures, which in some cases were enlarged by 800 percent."

SPECIAL COST-CUTTING TECHNIQUES: "Pictures from old catalogs are free until you get sued by the in-house legal staff of Penney's."

FIESTA POSTER

STUDIO: Cahan and Associates, San Francisco, CA

ART DIRECTOR: Bill Cahan

DESIGNER: Kevin Roberson

CLIENT/SERVICE: San Francisco Creative Alliance, WADC, Artists in Print/design education

TYPEFACE: Woodblock

CONCEPT: In order to capture the spirit and attitude of SOMA, the San Francisco neighborhood where Cahan and Associates is located, the studio created a series of posters influenced by the language of local street signs, such as corner store signage, local concert announcements and tabloid journals.

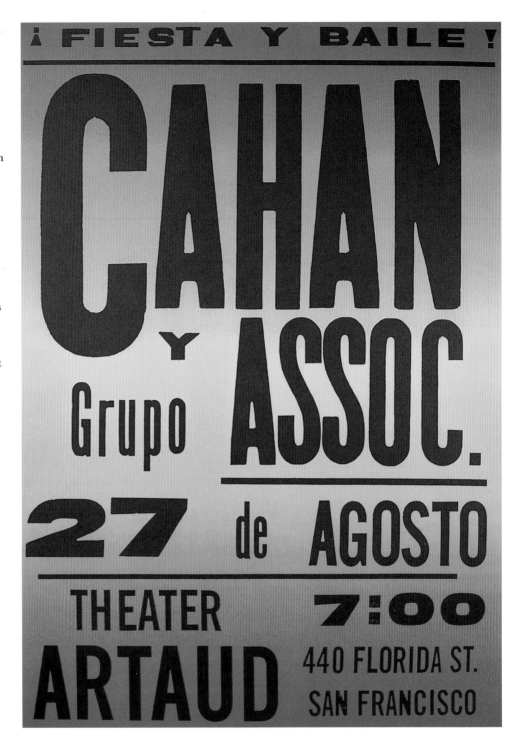

SIMPLE/COMPLEX POSTER

STUDIO: Cahan and Associates, San Francisco, CA

ART DIRECTOR: Bill Cahan

DESIGNER: Sharrie Brooks

ILLUSTRATOR: Sharrie Brooks

CLIENT/SERVICE: San Francisco Creative Alliance, WADC, Artists in Print/design education

SOFTWARE: QuarkXPress

COLORS: Four, process, plus two, match

PRINT RUN: 5,000

TYPEFACE: New Century Schoolbook

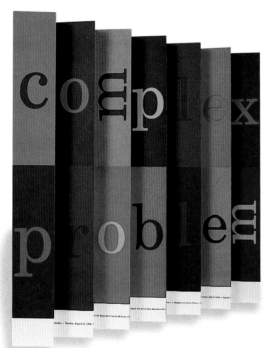

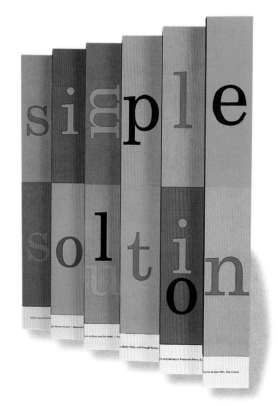

CONCEPT: This poster advertising a lecture by Bill Cahan, principal of Cahan and Associates, attempts to quickly communicate his studio's design philosophy of making the complex simple. This is accomplished through the use of type, color relationships and messaging. When viewing the poster from one side, it states "Complex Problems"; the other side reads, "Simple Solutions." Straight on, it looks like a cacophony of information, but when viewed from the right (or left) angle—when given some perspective and organization—the chaos starts making sense.

type in motion

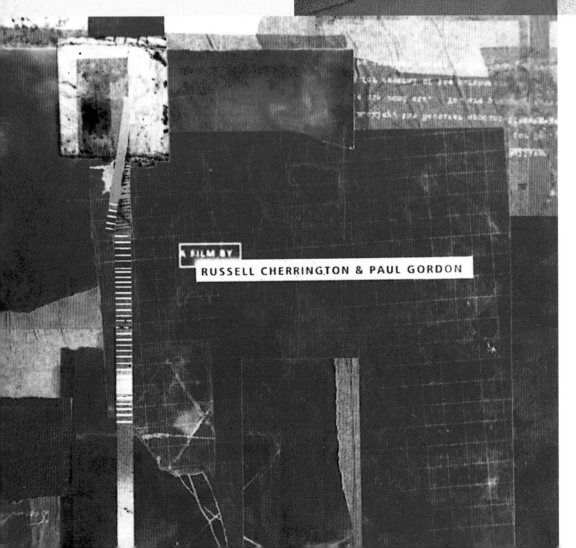

section SIX

A FILM BY
RUSSELL CHERRINGTON & PAUL GORDON

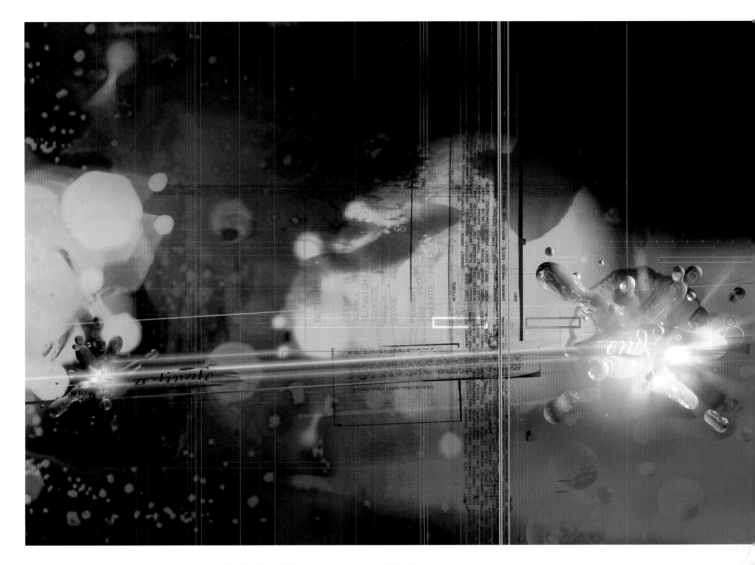

STUDIO: The Attik, Huddersfield and London, England, and New York, NY

PRESIDENT/EXECUTIVE PRODUCER: William Travis

GROUP CREATIVE DIRECTOR/ MANAGING DIRECTOR: James Sommerville

GROUP CREATIVE DIRECTOR/SALES DIRECTOR: Simon Needham

CREATIVE DIRECTOR, NEW YORK: Simon Dixon

DESIGNER: Simon Dixon

ILLUSTRATOR: Christian Perez

CLIENT/PRODUCT: Daniel Donnelly/ book featuring leading-edge web design

SOFTWARE: Macromedia FreeHand, Adobe Photoshop, Electric Image

COLORS: Four, process

CONCEPT: "This design was a section divider for a book on cutting-edge web design and development," says Simon Dixon. "The request was for free-form, edgy graphics to complement the innovative contributions of the book."

INSPIRATION: "The energy and movement of an online environment at a molecular level, a burst or byte of information within a fraction of time and size."

SPECIAL TYPE TECHNIQUES: The text was based on Din Mittleschrift, output onto photocopy paper, transferred to film, rephotocopied, scratched and damaged, and then scanned into the Mac.

"HOLD ME" FILM TITLES

STUDIOS: the shed, Ambleside, England, and storm, Ambleside, England

ART DIRECTORS/DESIGNERS: Russell Mills (the shed), Michael Webster (storm)

ILLUSTRATOR: Russell Mills

PHOTOGRAPHERS: Paul Gordon, Russell Cherrington

CLIENT/PRODUCT: Strange and Beautiful Productions/films

SOFTWARE: Adobe Photoshop, Adobe Illustrator, QuarkXPress

COLORS: Four, process

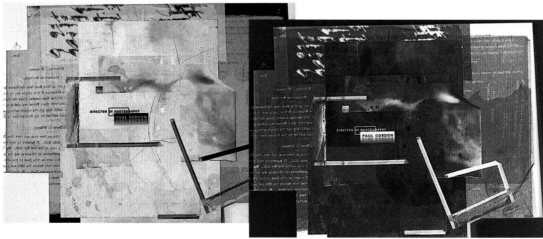

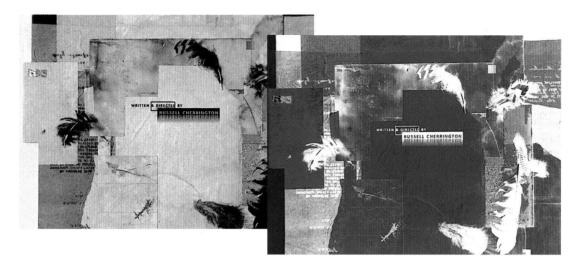

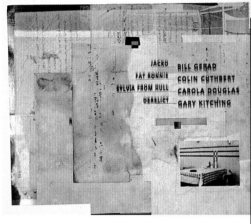
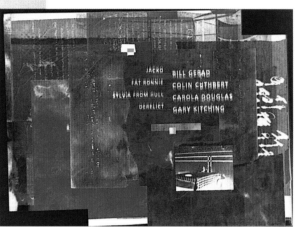

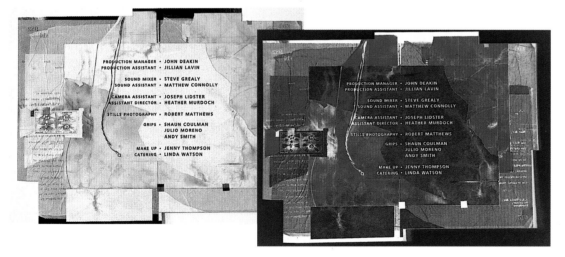

CONCEPT: Michael Webster says that these film opening titles "were used as part of the props in the film; on entering a derelict house, a roving handheld camera was used as the viewer's eyes, and when a title piece was stumbled upon, the movement froze. The then-captured title image flashed into negative (purple), then back into positive (beige); the camera then went on its way through this house stumbling on the rest of the titles with the same action taking place as with previous titles."

SPECIAL PRODUCTION TECHNIQUES: The titles were created with a combination of handmade collage and digital manipulation.

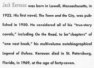

STUDIO: Paul Buckley Design, New York, NY

ART DIRECTOR/DESIGNER: Paul Buckley

PHOTOGRAPHER: FPG

CLIENT/SERVICE: Penguin Putnam Inc./publishing

SOFTWARE: QuarkXPress, Adobe Photoshop

COLORS: Five, match

PRINT RUN: 20,000

TYPEFACES: Constructa zmed (author name), August (title), Futura (text)

CONCEPT: Paul Buckley says of this *On the Road* cover design, "Getting a chance to design an anniversary hardcover version of possibly my favorite book was inspiration enough. Of course the greater reward brings with it greater pain if the project gets forced down a mediocre road, but working closely with editor David Stanford insured a very positive result—so much so that he agreed immediately when I requested displaying the moving last paragraph of the book, designed in very large type, on the back cover."

INSPIRATION: "Drinking and driving, American jazz," says Buckley.

STUDIO: Bureau, New York, NY

ART DIRECTORS/DESIGNERS: Marlene McCarty, Donald Moffett

DIRECTOR OF PHOTOGRAPHY: Russel Fine (for the typography)

CLIENT/PRODUCT: Fox Searchlight/movies

TYPEFACE: Futura

CONCEPT: In designing these opening titles for the Ang Lee film *The Ice Storm*, Marlene McCarty of Bureau says that she and Donald Moffett aimed to design something "with the organic quirks and unpredictability of nature."

SPECIAL TYPE TECHNIQUES: "Manipulation of light and typography through lens, glasses and refraction."

SPECIAL PRODUCTION TECHNIQUES: "This was a live film shoot, there was no computer manipulation involved."

SPECIAL COST-CUTTING TECHNIQUES: Avoiding traditional opticals

BURNOUT PROMOTIONAL QUICKTIME VIDEO

STUDIO: Todd Childers Graphic Design, Bowling Green, OH

ART DIRECTOR/DESIGNER: Todd Childers

PHOTOGRAPHER: Todd Childers

CLIENT/PRODUCT: T-26/fonts

SOFTWARE: Media 100, Adobe Premier, Adobe Photoshop

TYPEFACE: Burnout

TYPEFACE DESIGNER: Todd Childers

CONCEPT: To promote the release of his typeface Burnout, Todd Childers created this Quicktime video to be distributed on T-26's promotional CD-ROM.

INSPIRATION: "The great American roadside," says Childers.

SPECIAL TYPE TECHNIQUES: "Burnout is a product of my CalArts MFA thesis. I combined Gill Sans Bold, Franklin Gothic and Akzidenz Grotesk and altered them via Adobe Photoshop filters. Then I totally redrew the font in Adobe Illustrator, then imported the Illustrator outlines into Macromedia Fontographer for a final stage of refinement and production. The aesthetic goal of the project was to design a font that looked like it came from a glowing neon sign."

SPECIAL PRODUCTION TECHNIQUES: Adobe Photoshop filters, offset, Gaussian Blur

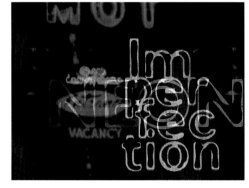

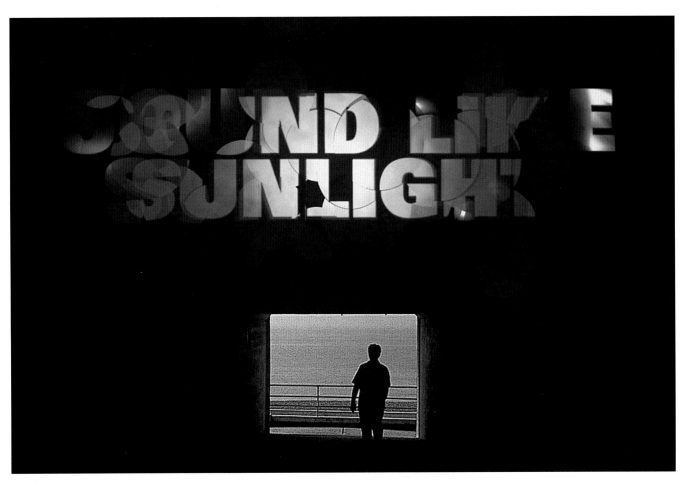

STUDIO: Eg.G, Sheffield, England

ART DIRECTOR/DESIGNER: Dom Raban

CLIENT/SERVICE: Between Films/film production

SOFTWARE: Infini-D, Adobe Photoshop, Adobe Illustrator

TYPEFACE: Univers

CONCEPT: Dom Raban says of this film title sequence, "*Sound Like Sunlight* is a documentary film (shot on 35mm) which looks at the lives of war-blinded patients at an English seaside hospital (St. Dunstan's). The type animation is closely linked with the sound track of an old soldier talking about the moment at which he lost his sight. Just as he describes the loss of sight, so the type blurs and disintegrates until the screen goes black."

SPECIAL TYPE TECHNIQUES: "The type was created as a mask for a light source in Infini-D. It was then projected onto a series of translucent discs which move in different planes."

SPECIAL PRODUCTION TECHNIQUES: "Individual sequential frames were rendered on the Macintosh and then transferred digitally to 35mm film by The Computer Film Company."

 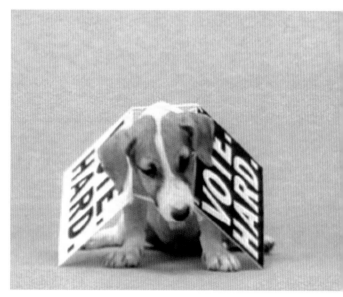

STUDIO: Bureau, New York, NY

ART DIRECTORS/DESIGNERS: Marlene McCarty, Donald Moffett

DIRECTOR OF PHOTOGRAPHY: Russel Fine

CLIENT/PRODUCT: MTV/music television

CONCEPT: "Donald and I wanted to do something that made us happy," says Marlene McCarty of this "Rock the Vote" spot Bureau developed for MTV.

INSPIRATION: "Jumbo, Freddy, Dottie and Buster (two cats and two dogs)."

SPECIAL TYPE TECHNIQUES: Miniature signboards

SPECIAL PRODUCTION TECHNIQUES: "Filming scads of friends' house-pets at a professional film shoot…in other words…*chaos.* Dogs were in the morning, cats in the afternoon. Cats need catnip to perform."

SPECIAL COST-CUTTING TECHNIQUES: "Hitting up our friends."

"KISS ME LIKE THE FIRST TIME"

STUDIO: Plazm Media, Inc., Portland, OR

ART DIRECTORS: Joshua Berger, Niko Courtelis, Pete McCracken

DESIGNER: Joshua Berger

PHOTOGRAPHER: Neva Knott

CLIENT/SERVICE: *Plazm* magazine/magazine publishing, digital type foundry, design

SOFTWARE: QuarkXPress, Adobe Photoshop

COLORS: One, black

PRINT RUN: 10,000

COST PER UNIT: $1.85 US

TYPEFACE: Roscent, Hybrid

TYPEFACE DESIGNERS: Angus R. Shamal (Roscent), Christian Küsters (Hybrid)

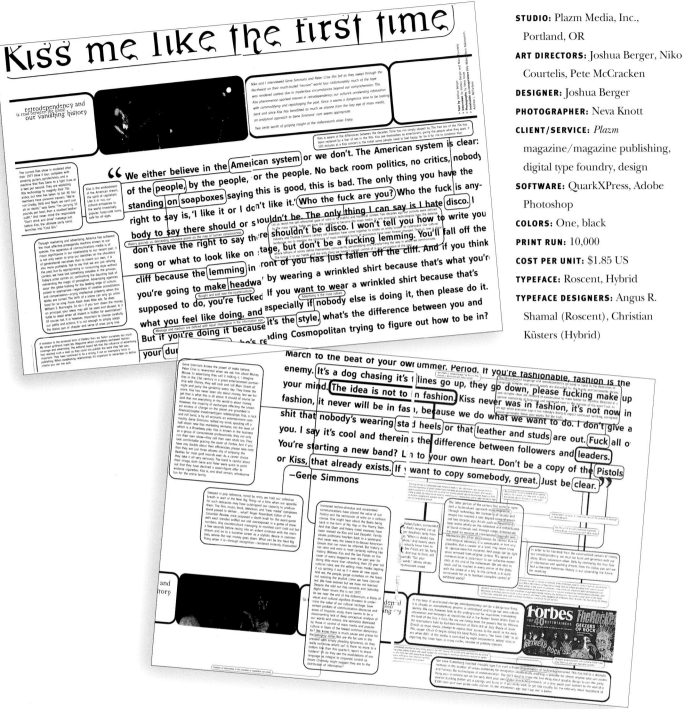

CONCEPT: "The concept was to use text from an interview Niko Courtelis and I had done with Gene Simmons of Kiss to discuss the cultural phenomenon of Retrodependency, our culture's unrelenting infatuation with commodifying and repackaging the past," says Joshua Berger of Plazm.

"The design approach allowed for nonlinear dissection and analysis of Gene's comments; as designer and writer I found this a flexible and intuitive method for working, allowing editing and design to occur around any given idea."

SPECIAL TYPE TECHNIQUES: The use of nonlinear text treatments.

STUDIO: Bureau, New York, NY

ART DIRECTOR/DESIGNER: Marlene McCarty, Donald Moffett

DIRECTOR OF PHOTOGRAPHY: Russel Fine

CLIENT/PRODUCT: Killer Films/feature films

TYPEFACE: Another Akzidenz font

CONCEPT: This film opening title sequence eschews computer manipulation in favor of a live action shoot on the movie set, with the opening title type being projected on, and then moved across, the film's office set.

fancy a change

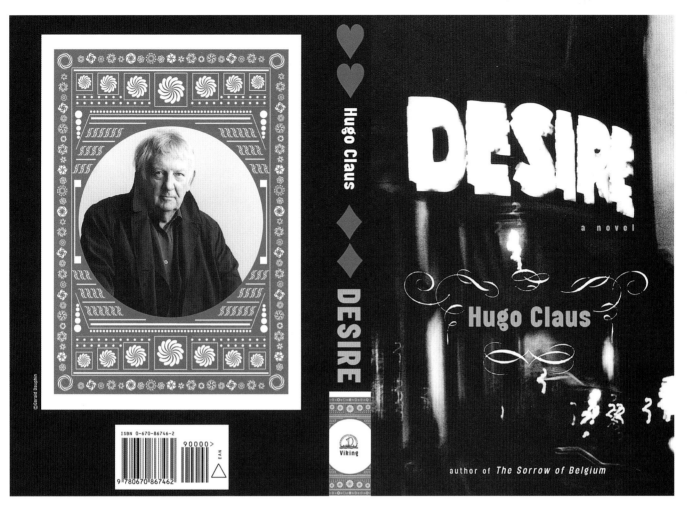

Gerald Dauphin

ISBN 0-670-86746-2
9 780670 867462
90000>
EAN

Hugo Claus
DESIRE

DESIRE
a novel
Hugo Claus
author of *The Sorrow of Belgium*
Viking

LONDON MOVING

STUDIO: The Attik, Huddersfield and London, England, and New York, NY

PRESIDENT/EXECUTIVE PRODUCER: William Travis

GROUP CREATIVE DIRECTOR/ MANAGING DIRECTOR: James Sommerville

GROUP CREATIVE DIRECTOR/SALES DIRECTOR: Simon Needham

CREATIVE DIRECTOR, NEW YORK: Simon Dixon

DESIGNER: Steven Wills

CLIENT/SERVICE: The Attik/design

SOFTWARE: Macromedia FreeHand, Adobe Photoshop, Infini-D

COLORS: Four, process

PRINT RUN: 2,000

TYPEFACE: Do One

TYPEFACE DESIGNER: Steven Wills

CONCEPT: Steven Wills says that this piece, which was created for a sales press pack for The Attik, was meant "to get across a highly technological theme which is where The Attik are at—showing the grittiness of where we came from."

INSPIRATION: "Speed, movement, technology and London."

SPECIAL TYPE TECHNIQUES: "Do One was conceived as a futuristic font for the next millennium. It is used for headers only. The outlined shapes were created in FreeHand and imported into Macromedia Fontographer where the kerning was sorted."

"DESIRE" BOOK COVER

STUDIO: Viking/Penguin, Inc., New York, NY

ART DIRECTOR: Paul Buckley

DESIGNER: Martin Ogolter

PHOTOGRAPHER: Ellen von Unwerth

CLIENT/SERVICE: Viking/Penguin/ publishing

SOFTWARE: QuarkXPress, Adobe Photoshop

COLORS: Four, process

PRINT RUN: 7,500

TYPEFACE: Elephant by alias

CONCEPT: "After several comps I came across this photograph in Ellen von Unwerth's book snaps," says Martin Ogolter of this cover design for the book *Desire*. "The two main characters basically live in a bar, so to have that wonderful moody shot even made sense to the editorial people, despite the hard-to-read type."

GEOFFREY BEENE "30"

STUDIO: Bureau, New York, NY

ART DIRECTORS/DESIGNERS: Marlene McCarty, Donald Moffett

DIRECTOR OF PHOTOGRAPHY: Ellen Kuras

CLIENT/PRODUCT: KVPI (Kalin Vachon Productions Inc.) for Geoffrey Beene/film

TYPEFACES: Various

CONCEPT: This opening type sequence introducing a film about clothing designer Geoffrey Beene's work uses the same grainy, black-and-white/Super 8 look that the rest of the opening sequence uses, with the title "30" flashing back and forth between a skewed and a straight treatment before finally settling on the skewed version, to which the name of the designer is then added.

SPECIAL TYPE TECHNIQUES: Says designer Marlene McCarty, "Shooting type in Super 8. Projecting that on a wall. Refilming the projection in 16mm. Blowing the 16mm up to 35mm."

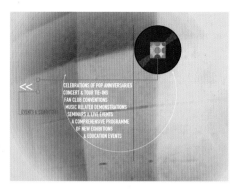

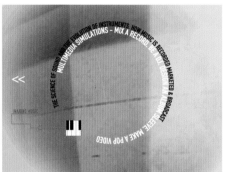
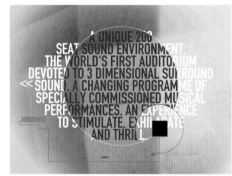
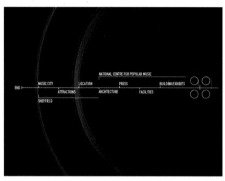

STUDIO: Eg.G, Sheffield, England

ART DIRECTOR: Dom Raban

DESIGNERS: Dom Raban, Dave Kirkwood

CLIENT/SERVICE: Music Heritage Ltd./exhibition centre

SOFTWARE: Macromedia Director, Infini-D, Adobe Photoshop, Adobe Illustrator

PRINT RUN: 4

COST PER UNIT: £2500 UK

TYPEFACE: DIN

CONCEPT: "The National Centre For Popular Music is Britain's newest exhibition centre, containing a range of interactive installations centering on the development of popular music," says Dom Raban. "However, at the time we created the CD-ROM the Centre existed only as a series of architect's plans, while the exhibits were still only at the conceptual stage. It was our job to create a CD which would give a flavor of the likely exhibits and the level of interactivity that they might provide. The design style is modern but does not draw on references which might link it to a particular genre or era of popular music, thus reflecting the broad base of the Centre's contents."

future shock

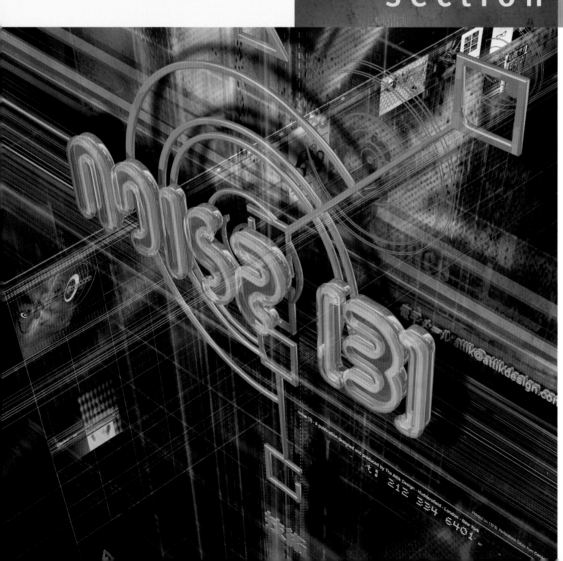

GRAVY FONT POSTER

ART DIRECTOR/DESIGNER/ILLUSTRATOR: Margo Chase

COPYWRITER: Nancy Loose

CLIENT/SERVICE: Margo Chase Design's Gravy Fonts, represented by [T-26]/type foundry

SOFTWARE: Adobe Illustrator, Adobe Photoshop, QuarkXPress

COLORS: Three, match

TYPEFACES: Box Gothic, Bradley, Edit, Envision, Kruella, Pterra, Vitriol, Portcullis, Tribe

TYPEFACE DESIGNERS: Margo Chase (Box Gothic, Bradley, Edit, Envision, Kruella, Pterra, Vitriol), Brian Hunt (Portcullis), Wendy Ferris Emery (Tribe)

CONCEPT: To create a poster that would showcase her entire line of Gravy Fonts, Margo Chase used old cookbooks as inspiration for the central saucy image, and Nancy Loose used bad recipe descriptions as inspiration for the copy. All play off the name of the foundry.

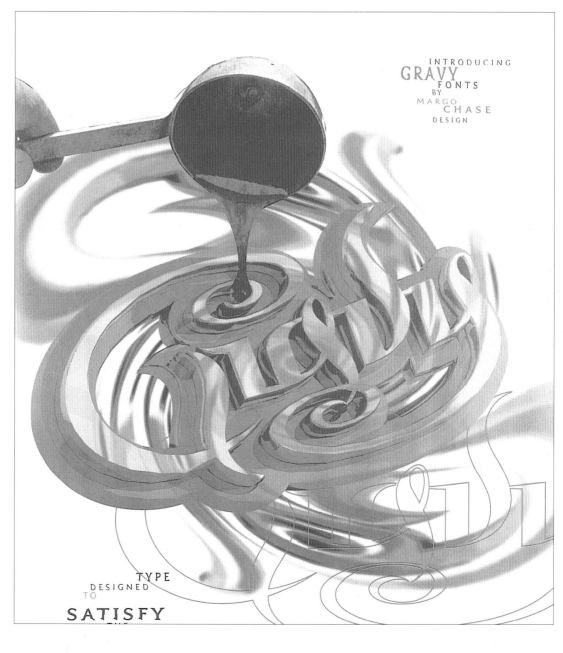

"PLAZM #13" ANNOUNCEMENT POSTER—"BANNED IN SINGAPORE"

STUDIO: Plazm Media, Inc., Portland, OR

ART DIRECTORS: Joshua Berger, Niko Courtelis, Pete McCracken

DESIGNERS: Donjiro Ban, Pete McCracken

CLIENT/PRODUCT: *Plazm* magazine/magazine, digital type foundry, design firm

SOFTWARE: QuarkXPress, Adobe Photoshop, Adobe Illustrator

COLORS: Three, match

PRINT RUN: 125

COST PER UNIT: $2.50 US

TYPEFACES: Characters from a Chinese newspaper, Microgamma (extended and outline), Mothra, wood type

TYPEFACE DESIGNER: Elliot Earls (Mothra)

CONCEPT: "This poster was created to announce *Plazm #13* but was also to be included in *Plazm*'s first collector's edition (which is still available)," says Pete McCracken of Plazm Media, Inc.

INSPIRATION: "The inspiration for this poster came from a letter we received from The Department of Undesirable Publication in Singapore, which banned *Plazm* from distribution in Singapore, stating that our magazine was not being let in because it was an undesirable publication."

SPECIAL PRODUCTION TECHNIQUES: The print run for this poster was two silkscreen runs and one letterpress run printed at Crack Press.

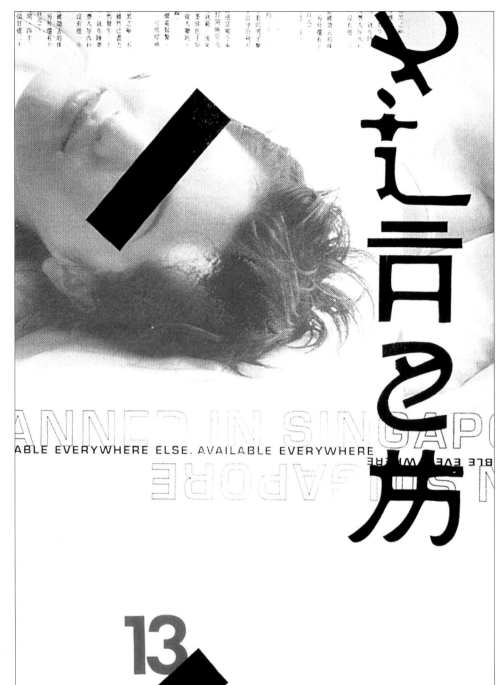

INVITATION FOR THE CONVENTO DO BEATO NEW YEAR'S EVE PARTY

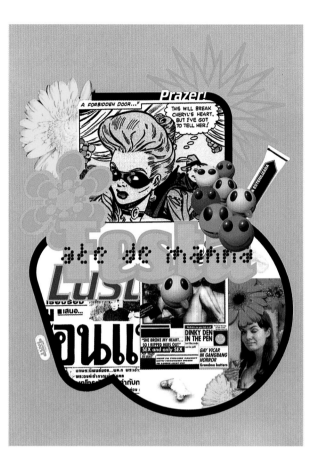

STUDIO: Centradesign, Lisbon, Portugal

ART DIRECTOR/DESIGNER: Ricardo Mealha

ILLUSTRATORS: Ana Margarida Cunha, João Bacelar

CLIENT/SERVICE: Bar Fragil/bar

SOFTWARE: QuarkXPress, Adobe Photoshop, Macromedia FreeHand

COLORS: Four, process, plus three, match, over four, process, plus one, match

PRINT RUN: 5,000

COST PER UNIT: $1.50 US

TYPEFACE: ModaLX

CONCEPT: "Our first experiment with 3-D programs" is how Ricardo Mealha describes this invitation. "We wanted to mix different graphic styles in a single piece."

SPECIAL TYPE TECHNIQUES: The main type is a modified Bodoni that Centradesign produced itself.

INVITATION FOR THE BAIRRO ALTO PARTY

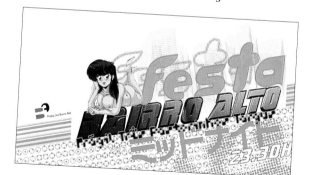

STUDIO: Centradesign, Lisbon, Portugal

ART DIRECTOR/DESIGNER: Ricardo Mealha

ILLUSTRATOR: João Bacelar

CLIENT/PRODUCT: Produções Bairro Alto/association of three Lisbon bars

SOFTWARE: QuarkXPress, Adobe Photoshop, Macromedia FreeHand

COLORS: Four, process, plus three, match

PRINT RUN: 1,000

COST PER UNIT: $.50 US

TYPEFACES: Helvetica, Letter Gothic, Japanese characters, type from *Star Trek* series

CONCEPT: "There was really no special theme for this party other than being a party sponsored by three trendy bars, so I suggested a Japanese Manga look and the client approved it," says designer Ricardo Mealha of this invitation.

SPECIAL TYPE TECHNIQUES: Some Japanese type was selected for its looks rather than its legibility.

SPECIAL PRODUCTION TECHNIQUES: This was a complex (and expensive) job—seven colors, including metallic and fluorescent colors, plus very thin lines on a very tight deadline.

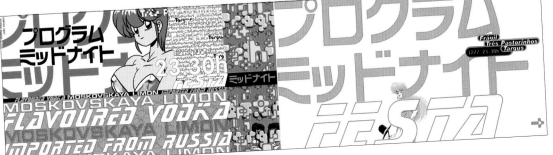

"ON THE ONE" MAGAZINE THIRD ANNIVERSARY ISSUE

STUDIO: *On The One*/Modern World Messengers, Inc., San Francisco, CA

ART DIRECTORS/DESIGNERS: Paul Craven, Paul Martinez

PHOTOGRAPHERS: Various

CLIENT/PRODUCT: *On The One/* quarterly music magazine

SOFTWARE: QuarkXpress, Adobe Photoshop

COLORS: Four, process, plus two, match

PRINT RUN: 10,000

COST PER UNIT: $1.29 US

TYPEFACES: Arrowmatic, Kryptic (titles), Garamond (body text)

CONCEPT: "The theme of our third anniversary issue was the future," says Paul Craven, one of the creative directors and publishers of *On the One.* "Paul Martinez and I decided that we wanted to create a totally new look for the magazine for this special issue. Since our magazine covers underground dance music (mainly jazz-based stuff), our concept for the original design was intended to have a retro look and feel similar to the old Blue Note album covers of the fifties and sixties. As the magazine progressed over the years, we began covering more electronic and drum and bass styles of music.

"For this special issue we decided to fax out a short questionnaire with various questions regarding the future. We sent this questionnaire to various cutting-edge producers, DJs, writers, designers, etc. We concentrated on keeping the editorial simple so that we could emphasize the new design. We also decided to add a fifth color (silver metallic) inside the book. For the one signature that didn't have

CMYK, we ran three spot colors.

"After discussing the theme and direction of the new look, Paul Martinez handled bringing it all together and designed the layout and format. We printed the magazine at a small local press and kept the page count down to keep

the costs down. All the money went into the production of the book and the additional colors. Paul used a combination of different design techniques in Photoshop and combined it with the typography in the book—mainly Kryptic and Arrowmatic."

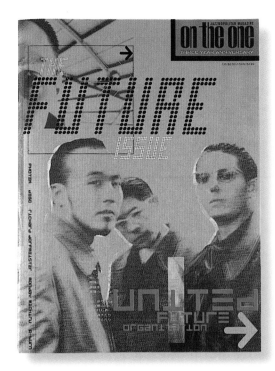

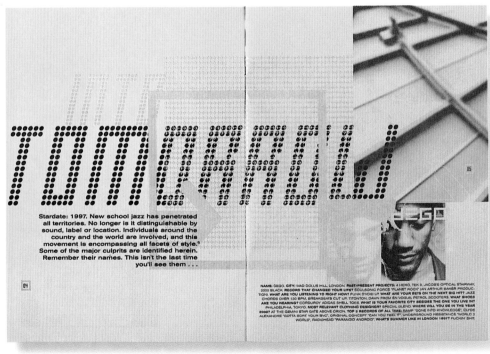

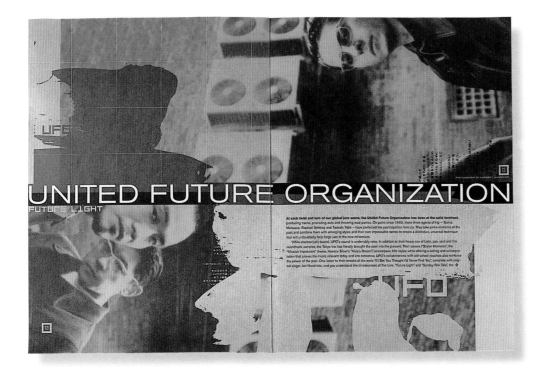

PHOTOGRAPHY BY NORBERT SCHOERNER

UNITED FUTURE ORGANIZATION
FUTURE LIGHT

At each twist and turn of our global jazz scene, the United Future Organization has been at the solid forefront, producing tracks, promoting acts and throwing mad parties. On point since 1990, these three agents of hip – Toshio Matsuura, Raphael Sebbag and Tadashi Yabe – have perfected the jazzmopolitan formula. They take prime elements of the past and combine them with emerging styles and their own impeccable tastes to create a distinctive, universal technique that will undoubtedly help forge jazz in the new millennium.

While electronically-based, UFO's sound is undeniably retro. In addition to their heavy use of Latin, jazz, soul and film soundtrack samples, the Tokyo trio has literally brought the past into the present. Their covers ("Stolen Moments", the "Mission Impossible" theme, Horace Silver's "Nica's Dream") encompass 60's styles while offering a setting and contemporization that proves the music relevant today and into tomorrow. UFO's collaborations with old-school vocalists also reinforce the power of the past. One listen to their remake of the eerie "I'll Bet You Thought I'd Never Find You", complete with original singer Jon Hendricks, and you understand the timelessness of the tune. "Future Light" and "Sunday Folk Talk", the

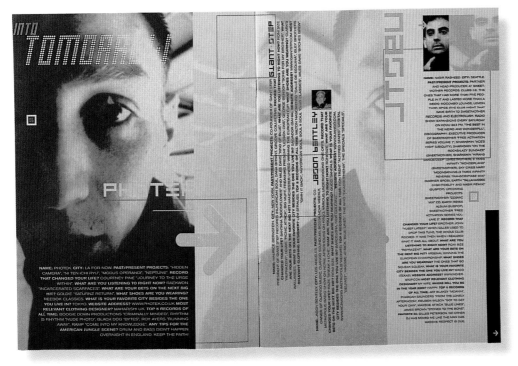

INTO TOMORROW

PHOTEK

GIANT STEP

JASON bENTLEY

NASIR

NAME: PHOTEK. **CITY:** LA FOR NOW. **PAST/PRESENT PROJECTS:** "HIDDEN CAMERA", "NI TEN ICHI RYU", "MODUS OPERANDI", "NEPTUNE". **RECORD THAT CHANGED YOUR LIFE?** COURTNEY PINE "JOURNEY TO THE URGE WITHIN". **WHAT ARE YOU LISTENING TO RIGHT NOW?** RADIKON "INCARCERATED SCARFACES". **WHAT ARE YOUR BETS ON THE NEXT BIG HIT?** GOLDIE "SATURNZ RETURN". **WHAT SHOES ARE YOU WEARING?** REEBOK CLASSICS. **WHAT IS YOUR FAVORITE CITY BESIDES THE ONE YOU LIVE IN?** TOKYO. **WEBSITE ADDRESS?** WWW.PHOTEK.CO.UK. **MOST RELEVANT CLOTHING DESIGNER?** MAHARISHI UK. **TOP 5 RECORDS OF ALL TIME:** BOOGIE DOWN PRODUCTIONS "CRIMINALLY MINDED", RHYTHM IS RHYTHM "NUDE PHOTO", BLACK DOG "BYTES", ROY AYERS "RUNNING AWAY", RAMP "COME INTO MY KNOWLEDGE". **ANY TIPS FOR THE AMERICAN JUNGLE SCENE?** DRUM AND BASS DIDN'T HAPPEN OVERNIGHT IN ENGLAND. KEEP THE FAITH!

NAME: JASON BENTLEY. **CITY:** LOS ANGELES. **PAST/PRESENT PROJECTS:** CO-FOUNDER OF GIANT STEP RECORDS (N.Y.)/COCA SOUND, DANA BRYANT, GROOVE COLLECTIVE). **RECORD THAT CHANGED YOUR LIFE?** "KIND OF BLUE". **WHAT ARE YOU LISTENING TO RIGHT NOW?** RONI SIZE "REPRAZENT", GEORGE BENSON "GOING FOR IT" BROTHER! **WHAT ARE YOUR BETS ON THE NEXT BIG HIT?** MANCHESTER UNITED WINNING THE EUROPEAN CUP. **WHAT SHOES ARE YOU WEARING?** GUCCI SANDALS. **WHAT IS YOUR FAVORITE CITY BESIDES THE ONE YOU LIVE IN?** LONDON. **WEBSITE ADDRESS?** WWW.QUANGO.COM. **MOST RELEVANT CLOTHING DESIGNER?** LEVI STRAUSS. **TOP 5 RECORDS OF ALL TIME:** MILES DAVIS "BITCHES BREW", RON TRENT "ALTERED STATES", ORBITAL, MOON NAGHAM, SOUL II SOUL "BACK TO LIFE", KRAFTWERK "THE SPECIALS "SPECIALS". "DAN IT BACK", NAUGHTY SOUL II SOUL "BACK TO LIFE".

NAME: NASIR RASHEED. **CITY:** SEATTLE. **PAST/PRESENT PROJECTS:** PARTNER AND HEAD PRODUCER AT SWEET-MOTHER RECORDS. **CLUBS I.E. THE ONES THAT HAD MORE THAN FIVE PEOPLE IN IT AND LASTED MORE THAN A WEEK:** MOCOMBO LOUNGE, LEMON TWIST, SPICE (THE CLUB NIGHT THAT GAVE BIRTH TO SWEETMOTHER RECORDS AND ELECTRO/LUSH. RADIO SHOW: EXPANDING EVERY SATURDAY ON KCMU 90.3 FM, "THE BEST IN THE WEIRD AND WONDERFUL". **DISCOGRAPHY:** EXECUTIVE PRODUCER OF SWEETMOTHER 'FREE ACTIVATION SERIES VOLUME 1', SHARKSKIN "ACES HIGH" (UBIQUITY), SHARKSKIN "ON THE ROCKS/LAZY SUNDAZE" (SWEETMOTHER), SHARKSKIN "KRANG DANCE/DEEP" (SWEETMOTHER), 3 TIMES INFINITY "WONDERLAND" (SWEETMOTHER), SKY CRISS MARY "MOONSHINING (3 TIMES INFINITY REVERSE TRANSCRIPT/ASB MIX)" (WARNER BROS), EARTH "TALLAHASSEE (HIGH FIDELITY AND NASIR REMIX)" (SUBPOP). **UPCOMING PROJECTS:** SWEETMOTHER "COSMIC MIX" CD, EARTH REMIX ALBUM (SUBPOP), SWEETMOTHER 'FREE ACTIVATION SERIES VOL-UME 2'. **RECORD THAT CHANGED YOUR LIFE?** BROTHER JOHN "YUSEF LATEEF". WHEN GILLES USED TO DROP THIS TUNE, THE WHOLE CLUB ROCKED. IT WAS THEN WHEN I REALIZED WHAT IT WAS ALL ABOUT. **WHAT ARE YOU LISTENING TO RIGHT NOW?** RONI SIZE "REPRAZENT". **WHAT ARE YOUR BETS ON THE NEXT BIG HIT?** ARSENAL WINNING THE EUROPEAN CHAMPIONSHIP. **WHAT SHOES ARE YOU WEARING?** THE ONES THAT GO SQUEAK SQUEAK. **WHAT IS YOUR FAVORITE CITY BESIDES THE ONE YOU LIVE IN?** WACO (TEXAS). **WEBSITE ADDRESS?** WWW.NEVER STOP.COM. **MOST RELEVANT CLOTHING DESIGNER?** MY WIFE; WHERE WILL YOU BE IN THE YEAR 2000? HAPPY. **TOP 6 RECORDS OF ALL TIME:** ART BLAKEY "MOANIN", PHAROAH SAUNDERS "FROM THE LONELY AFTERNOON", REUBEN WILSON "GOT TO GET YOUR OWN", MASSIVE ATTACK "TRUE LINES", JAMES BROWN "STONED TO THE BONE". **FAVORITE DJ:** GILLES PETERSON. NO OTHER DJ HAS MOVED ME LIKE THE MAN HAS. MASSIVE RESPECT IS DUE.

→

SHOWROOM

STUDIO: Eg.G, Sheffield, England

ART DIRECTOR/DESIGNER: Dom
Raban

PHOTOGRAPHER: Patrick Henry

CLIENT/SERVICE: Mem
Morrison/theatre company

SOFTWARE: Adobe Illustrator, Adobe
Photoshop

COLORS: Four, process

PRINT RUN: 6,000

COST PER UNIT: £0.20 UK

TYPEFACES: Trade Gothic, Berthold
City

CONCEPT: "As with all arts theatre
companies the budget was very
limited," says Dom Raban of this
combination poster/flyer he creat-
ed to promote the theater piece
Showroom. "The client needed
posters and flyers but could not
afford both so we designed the
poster so that it could also be
trimmed into six different flyers.
This created a design headache
but left a very happy client with a
poster, six different flyers and
some small change left in the bud-
get!" The piece that results refer-
ences the show it promotes by
employing props from it.

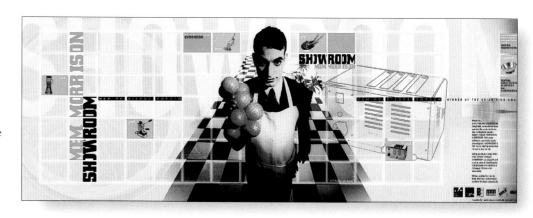

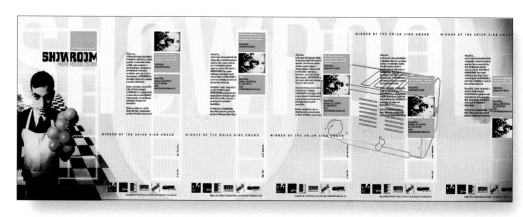

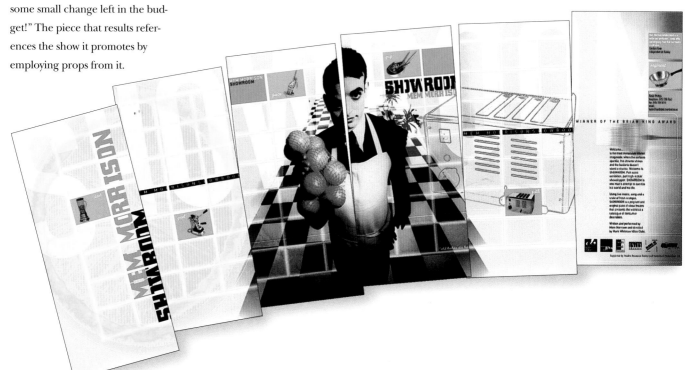

NOVA TYPE SAMPLE POSTER

STUDIO: REY International, Los Angeles, CA

ART DIRECTOR/DESIGNER: Greg Lindy

CLIENT/PRODUCT: Lux Typographics/digital type

SOFTWARE: QuarkXPress, Adobe Photoshop

COLORS: Two, match

PRINT RUN: 1,000

COST PER UNIT: $.50 US

TYPEFACE: L.Nova

TYPEFACE DESIGNER: Greg Lindy

CONCEPT: According to Greg Lindy, this poster—created to announce the birth of his typeface L.Nova—"shows the application of this new font in various scenarios. At one level the viewer is invited to see the precision of design of the font with it displayed large. Also, the font is set as text to demonstrate how legible it really is. The imagery signifies birth and the literary. Some of the text proposes that the font was in fact designed, or born, with its 'mutation' as opposed to being edited away."

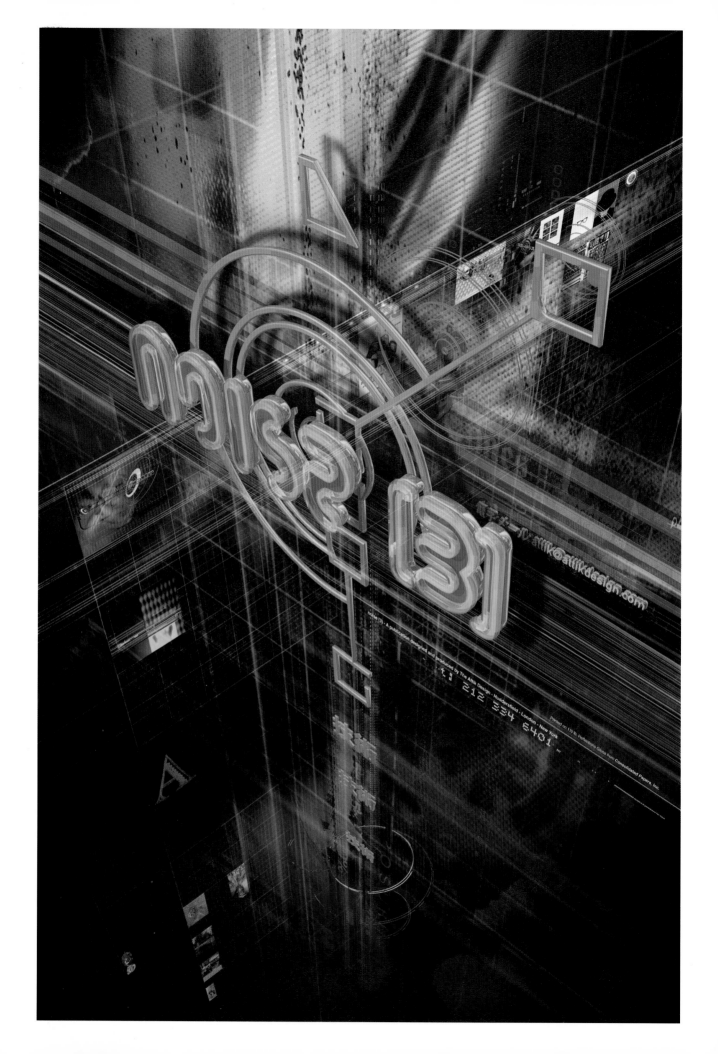

"NOISE (3)" POSTER

STUDIO: The Attik, Huddersfield and London, England, and New York, NY

PRESIDENT/EXECUTIVE PRODUCER: William Travis

GROUP CREATIVE DIRECTOR/ MANAGING DIRECTOR: James Sommerville

GROUP CREATIVE DIRECTOR/SALES DIRECTOR: Simon Needham

CREATIVE DIRECTOR, NEW YORK: Simon Dixon

DESIGNER: Simon Dixon

CLIENT/SERVICE: The Attik/design

SOFTWARE: Adobe Photoshop, Macromedia FreeHand, Adobe Illustrator, Strata-Pro

COLORS: Four, process

PRINT RUN: 3,000

CONCEPT: This poster was an advertisement for a design publication The Attik produced sporadically. The poster was to reflect the depth and innovation of the book's contents. "*Noise* is a vehicle for the designers at The Attik," says Simon Dixon, "the chance to develop and originate new ideas and directions, push the boundaries of a printed document."

In creating the design for this poster, Simon Dixon says that he meant to create "an environment that was totally dimensional indicating infinite possibilities. The intention was to show or capture a moment/frame that hints at a bigger picture, making a statement about the endless physical parameters of the *Noise* project. There was also a reference to the detail and complexity of a project of this size and the amount of digital information it contains."

SPECIAL TYPE TECHNIQUES: The type for the title, based on simple curved geometric shapes and several rounded typefaces, was created specifically for the poster. Drawn initially in FreeHand, it was re-created in Strata-Pro to make it a dimensional object. It was then lit and angled to fit the intended layout.

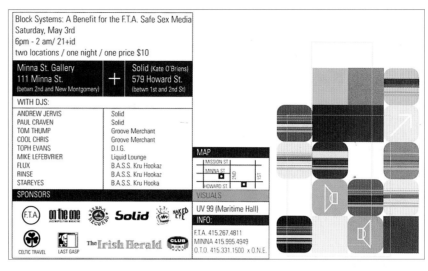

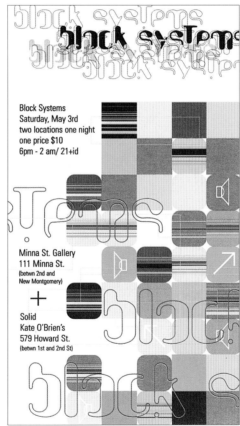

STUDIO: Ninth Vibe Graphics, San Francisco, CA

ART DIRECTOR/DESIGNER: Paul Craven

CLIENT/SERVICE: Several promoters, including *On the One* and *Solid*/event promotion

SOFTWARE: QuarkXPress, Adobe Photoshop, Adobe Illustrator

COLORS: Four, process

PRINT RUN: 10,000

COST PER UNIT: $.04 US

TYPEFACES: Blur, Universe

CONCEPT: For this flyer promoting a benefit party entitled Block Systems, Paul Craven says, "I played off the theme of 'Block Systems' and created many different blocks with different color palettes. The end result was a beautiful abstract collage of color."

CLICHÉ CARDS

STUDIO: Margo Chase Design, Los Angeles, CA

ART DIRECTOR/DESIGNER: Margo Chase

ILLUSTRATOR: Margo Chase

CLIENTS/SERVICES: Westland Graphics; Margo Chase Design/full-service printer; design firm

SOFTWARE: Adobe Illustrator, Adobe Photoshop, Infini-D

COLORS: Four, process, plus registered spot UV

TYPEFACES: Custom-designed

TYPEFACE DESIGNER: Margo Chase

CONCEPT: For this joint self-promotion piece for Margo Chase Design and Westland Graphics, the idea was to redefine ancient clichés and give them a contemporary feel. Margo Chase Design created a series of six cards and envelopes packaged like a "gift" that both companies could give out as samples/premiums.

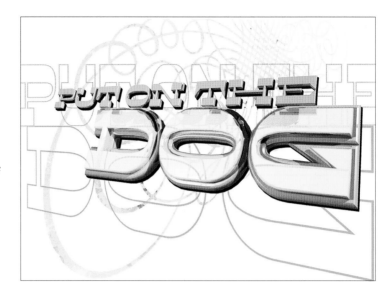

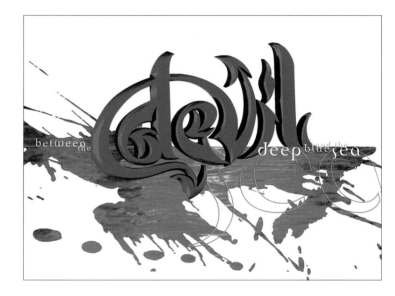

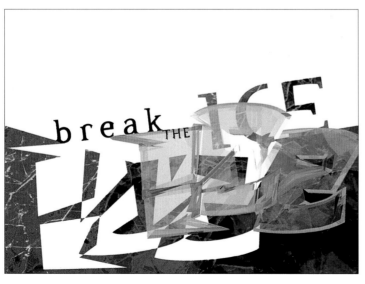

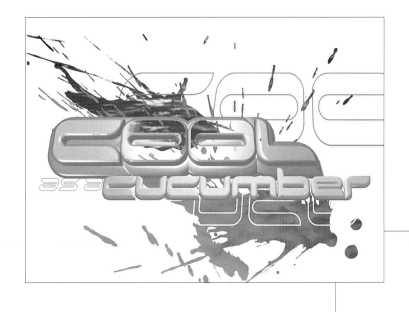

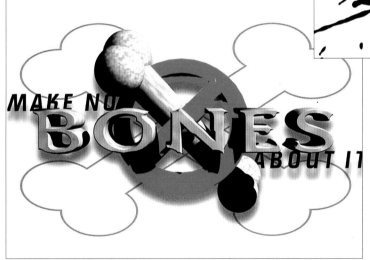

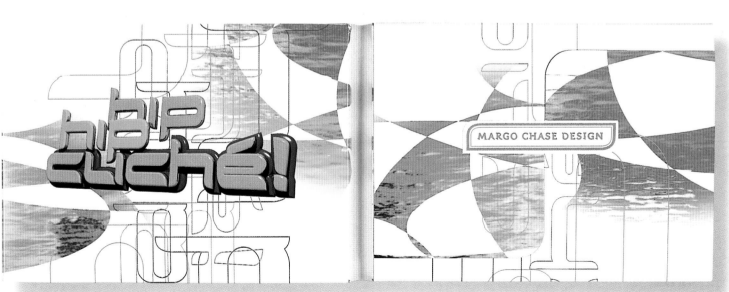

REY INTERNATIONAL ENVELOPE INSERTS

STUDIO: REY International, Los Angeles, CA

ART DIRECTOR/DESIGNER: Greg Lindy

CLIENT/SERVICE: REY International/graphic design

SOFTWARE: QuarkXPress

COLORS: One, match

PRINT RUN: 300 each

COST PER UNIT: $.30 US

TYPEFACES: Gill Sans, Akzidenz Grotesk, SolCircle

TYPEFACE DESIGNERS: Eric Gill (Gill Sans), Greg Lindy (SolCircle)

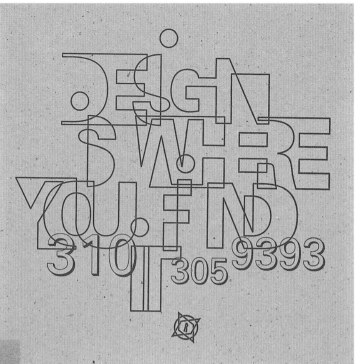

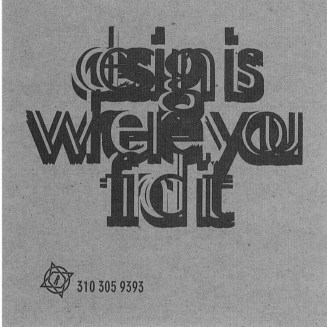

CONCEPT: These letterpressed cardboard envelope inserts "create an interesting display of our motto, 'Design is where you find it,'" says Greg Lindy. "We had done various versions over time; the first two were literal in their read. However, for the third, I replaced the readable font with an abstract one. Hopefully, people that had received the first two would sense the meaning behind the abstraction. If not, at least they would be left thinking, 'what the heck does it mean!'"

INDEX

copyright NOTICES

SO YOU THINK YOU'RE ON THE EDGE...

If you'd like for your work to be considered for the next Creative Edge book, please copy the form below (or include the same information in a note to us) and send it to:

Linda Hwang
Creative Edge mailing list
North Light Books
1507 Dana Avenue
Cincinnati, OH 45207

or call Linda at (513) 531-2222, fax her at (513) 531-4744, or E-mail her (LindaH@fwpubs.com). Who knows—maybe you've got the edge we're looking for.

- -

Please put me on your mailing list to receive calls for entries for future Creative Edge books.

My name _____

Studio name _____

Address _____

City _____

State _____Zip Code_____

Country _____

Phone _____

Fax _____

E-mail_____

DESIGNED WITH YOU IN MIND!
MORE GREAT BOOKS FOR GRAPHIC DESIGNERS.

1999 Artist's & Graphic Designer's Market—This marketing tool for fine artists and graphic designers includes listings of 2,500 buyers across the country and helpful advice on selling and showing your work from top art and design professionals. #10556/$24.99/720 pages

Cool Type—A showcase of the best in contemporary typefaces, this spectacular collection contains bios and innovative designs from Chip Kidd, Fred Woodward, Bruce Mau and 40 other modern type artists. #30887/$34.99/144 pages/292 color illus.

Creative Edge Page Design—Learn the techniques of the pros as an international crew of well-known and up-and-coming design visionaries discuss their featured magazine and book designs, brochures, ads and posters, revealing how they achieved the "creative edge" in every piece. #31210/$29.99/144 pages/339 color illus.

Creative Low-Budget Publication Design—If you've ever struggled to create high-impact work on a shoestring budget, then this book's for you! It features dozens of case studies with complete production specs, client information, original design concept and objectives. #31339/$29.99/144 pages/200 color illus.

Designer's Guide to Marketing—Over 40 full-color examples illustrate the dynamics of marketing strategy in graphic design with clear, easy-to-understand explanations of marketing basics—from product development to pricing, distribution and promotion. If you want to be successful, this is where you need to start. #30932/$29.99/144 pages/112 color, 24 b&w illus.

Digital Focus—A revolutionary look at how the best in the business fuse photography with digital effects. If you're a creative visionary, this book is a must-have. Its powerful images showcase the work of the best new media photographers in advertising and publishing. #30978/$39.95/176 pages/300 color illus.

Getting Started in Multimedia Design—Gary Olsen offers you creative advice, business tips and other secrets of success. If you're a designer who wants to start creating Web sites, interactive CDs or any other type of multimedia design, this book's for you. #30886/$29.99/144 pages/176 color illus.

Graphic Artist's Guild Handbook of Pricing & Ethical Guidelines, 9th Edition—The latest, essential information on business, pricing and ethical standards for nearly every discipline in the visual communications industry—from advertising to publishing to corporate markets. #30896/$29.95/328 pages

Graphic Design: Inspirations and Innovations—Today's top design talents discuss how they work, from the creative process to fostering strong client relationships. This book features more than 200 examples of classic and progressive work. #31181/$24.99/144 pages/201 color illus.

Graphic Design: Inspirations and Innovations 2—With quick, creative thinking, 39 top designers show you how they dealt with unexpected situations—from earthquakes to typos—and came out with some of their finest work! #30930/$29.99/144 pages/177 color illus.

Graphic Design Tricks & Techniques—This is the one place where you can get time- and cost-saving ideas to get fantastic results in design, production, printing and more. This guide shares you how the smart designers, photographers, typographers, prepress and printing experts across the U.S. and Canada design better, faster, easier and cheaper—practical advice designers demand most. #30919/$27.99/144 pages/99 color, 19 b&w illus.

Great Production by Design—Constance J. Sidles, the "Tech Tips" columnist for HOW magazine, shares the critical information you need to create production-friendly design that is true to concept, color and cost estimates—all delivered with full-color illustrations and clear language you can easily understand. #31136/$27.99/144 pages/147 color, 21 b&w illus

How to Break Into Product Design—Based on the real-life experiences of 20 successful graphic-designers-turned-product-marketers, this sourcebook shows you how to come up with a viable product idea, then walks it through the product design and development process, from concept, prototyping and testing—all the way to pricing, promotion and distribution. #31119/$27.99/144 pages/107 color illus.

How to Understand and Use Design and Layout—The often-confusing details of design and layout are explained in simple, understandable principles—then applied to every type of design project. You'll be guided through each step of effective design—from exploring basic design options to making decisions about type and layout. #30273/$22.99/144 pages/200 color, 175 b&w illus.

Make Your Scanner a Great Design and Production Tool, Revised Edition—Your must-have guide to successful scanning is now updated with the latest information on storage media, scanning for the Web, digital cameras, scanning hardware and software. #31113/$28.99/160 pages/222 color, 120 b&w illus.

The Streetwise Guide to Freelance Design and Illustration—This information-packed book guides aspiring freelance designers through every step of developing a successful design business, from setting up a home office to pricing. #33111/$24.99/144 pages/66 color illus.

Thinking Creatively: New Ways to Unlock Your Visual Imagination—Robin Landa makes great visual communication easy, by teaching you how to generate design ideas with bold graphic impact. You'll jump start your graphic-thinking ability with exercises, advice from top professionals, and unique idea-generating techniques. #31205/$29.99/160 pages/250+ color illus.

Typographics 1—This daring, international collection of 270+ works from professional and student typographers shows you the explosion of type innovations and experimentation happening around the world. #30950/$34.95/224 pages/270 color illus.

Typographics 2: Cybertype—Outstanding and innovative magazine design from around the globe focuses on the cutting-edge typography known as cybertype. More than 260 full-color examples are featured. #31128/$35.00/244 pages/260+ color illus.

Typography Now 2—An all-new showcase of the energetic work that's driving typography today—from the most extreme "garage fonts" to the new digital typefonts. Keep yourself on the cutting edge. #31223/$35.00/240 pages/250+ color illus.